IMAGES
of America

CAL FIRE
SAN BERNARDINO, INYO,
AND MONO COUNTIES

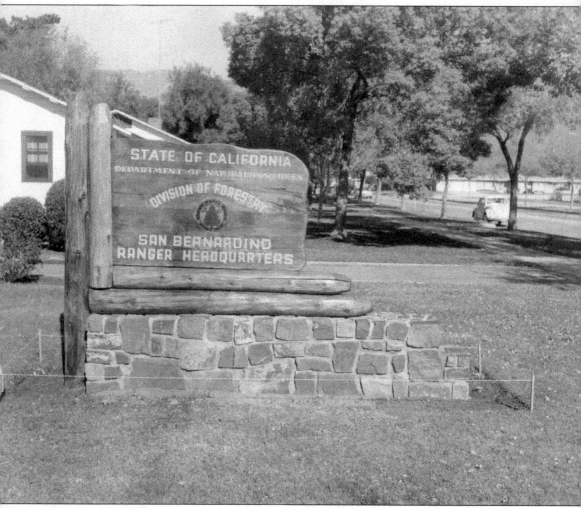

The CAL FIRE station signs, such as this one, were constructed of redwood with a pine post. Station firefighters obtained rocks from creek beds and built a rock base. In the early 1960s, the California Division of Forestry established handbook policy No. 2320, providing uniformity of department signs. Signs could be made of wood or metal. (Courtesy of CAL FIRE Museum and Historical Society.)

On the Cover: Forestry fire foreman Bob Clanton, standing, and Rudy Aleman, rear facing forward, of Engine 578 from Yucaipa are parked at the Lake Arrowhead Dam. In September 1956, a brushfire that was thought to have been caused by arson threatened the north shore of Lake Arrowhead. Another fire that threatened Lake Arrowhead was caused by the crash of a military F-100C Super Sabre from George Air Force Base. (Courtesy of CAL FIRE Museum and Historical Society.)

IMAGES
of America

CAL FIRE
SAN BERNARDINO, INYO, AND MONO COUNTIES

Steve Maurer and the CAL FIRE Museum

ARCADIA
PUBLISHING

Published by Arcadia Publishing
Charleston, South Carolina

Library of Congress Control Number: 2015955332

For all general information, please contact Arcadia Publishing:
Telephone 843-853-2070
Fax 843-853-0044
E-mail sales@arcadiapublishing.com
For customer service and orders:
Toll-Free 1-888-313-2665

Visit us on the Internet at www.arcadiapublishing.com

CONTENTS

ACKNOWLEDGMENTS

I wish to thank the following individuals for their support and encouragement while researching and writing this book. Thanks go to Jerry Glover, Glen Newman, and Fred Schmidt for their institutional knowledge of the California Department of Forestry (CAL FIRE) and its people. I also thank Craig Williams and John Sanders who helped with photographs and information for the Inyo-Mono division. Previous Arcadia Publishing author Claire Marie Teeters, of the Yucaipa Valley Historical Society, provided encouragement and shared her knowledge about the book-writing process.

The California State Archives research desk staff was also helpful with locating archived photographs, and so were Genevieve Preston and Kris Kunze, of the San Bernardino County Archives, with guiding me through volumes of records.

This book would not have been possible without the generous donations of photographs and artifacts made by forestry members past and present. And a special thank-you goes to those dumpster-diving firefighters who recognize the historical value of outdated relics no longer appreciated at the fire station.

All photographs, unless not otherwise indicated, are the property of the CAL FIRE Museum and Historical Society.

INTRODUCTION

Ever since the first act to approve the California State Board of Forestry on March 3, 1885, the citizens of San Bernardino County have been actively involved with efforts to preserve forestry lands and watershed from destruction from fire. Early pioneers of San Bernardino County volunteered their services for the protection of their communities, and more importantly, their crops, which depended on the valuable watershed of the San Bernardino Mountains.

In a letter to the California State Board of Forestry, early pioneer Augustus "Gus" Knight Jr. described his efforts in posting notices and keeping sheep from the finest timber areas in the Bear Valley district of the San Bernardino Mountains.

Other landowners donated tracts of land to the state board for the use of developing tree nurseries for reforestation efforts in fire-scarred districts, such as the land donated by the Hesperia Land and Water Company near the Santa Fe tracks and Mojave Street in the Hesperia community. With the demise of the first California State Board of Forestry in 1893, the majority of this land reverted back to the donors.

In 1905, with a newly established California State Board of Forestry and the position of a state forester, the state again utilized local citizens to guard against destruction of the local watershed. Many of the local US Forest Service rangers were appointed by the California state forester to act as agents of the State of California. One of the first lists of locally appointed voluntary fire wardens was presented September 25, 1907, in the *San Bernardino Daily Sun* newspaper. The fire wardens of that time used conscription laws, which allowed them to muster large forces of men to fight forest fires.

The State of California would not start adequately budgeting the division of forestry until 1931, when the division of forestry hired its first "standby" crews. In the meantime, the US Forest Service and county governments provided protection to the California Division of Forestry lands. In 1925, San Bernardino County, in an effort to obtain federal funds for reforestation, established the San Bernardino County Forestry Department and appointed Roy M. Tuttle as county forester and fire warden, a position he would hold until his resignation on January 31, 1929.

At the urging of the San Bernardino County Board of Forestry, the San Bernardino County Board of Supervisors entered into a contractual cooperative agreement between the California Division of Forestry and San Bernardino County on August 1, 1930, for the suppression and prevention of fire within San Bernardino County. This cooperative agreement survived 68 years until the San Bernardino County Board of Supervisors chose to terminate the contract.

Although the San Bernardino County Board of Supervisors cancelled this agreement July 1, 1998, the cities of Highland and Yucaipa chose to continue having the California Department of Forestry provide fire protection services to their citizens. CAL FIRE continues to evolve and grow within San Bernardino County.

In 1989, State Responsibility Area land within Inyo and Mono Counties was consolidated under the management of the San Bernardino Unit of the California Department of Forestry to include Owens Valley Camp, Bishop Forestry Fire Station, and Independence Station. The unit including Inyo and Mono Counties was created by the California Division of Forestry in 1963 with Curtis Lindley as its first ranger in charge. Owens Valley Camp through the years has provided many crew hours constructing trails in Death Valley and working with the US Forest Service on the Pacific Crest Trail.

Ever since Smokey Bear, many firefighters have spent their time at fairgrounds, ball games, and local events, providing Smokey's fire safety tips to children and adults. As early as 1953, the California Division of Forestry, cooperating with the San Bernardino National Forest, had a presence at the San Bernardino National Orange Show fairgrounds. Along with Smokey, Miss Fire Prevention appeared at ball games, car races, and county fairs throughout San Bernardino County. Each year at the tri-county fair, in Bishop, California, CAL FIRE employees from Bishop and Independence provide fire prevention and conservation information to fairgoers.

In 1999, a small group of California Department of Forestry retirees, led by Jerry Glover from San Bernardino, had the inspiration to establish a historical society and museum dedicated to the collection and preservation of all aspects relating to the California Department of Forestry. Through the determination of Jerry Glover and the support of the founding members, in January 2000, the Historical Society and Museum for the California Department of Forestry was established. Founding members were Jerry Glover, Fred Schmidt, Dan Lang, Jan Newman, Ernie Balmforth, Jim Wagner, and Denny Strong.

One

FORMATIVE YEARS OF
THE STATE DIVISION
OF FORESTRY

On March 3, 1885, Gov. George Stoneman signed legislation that established the first California State Board of Forestry. Agents to the board of forestry were appointed in various counties. Capt. E.A. Smith was appointed commissioner, and August "Gus" Knight Jr. was named an agent to the board of forestry for San Bernardino County. Other actions occurred to support the early forestry efforts in San Bernardino County, such as the Hesperia Land and Water Company donating 20 acres of land near the Santa Fe tracks and Mojave Street for use as a forestry nursery. Unfortunately, Governor Stoneman signed legislation dissolving the early board in 1893.

On March 18, 1905, the California state legislature approved the establishment of a new California State Board of Forestry, appointing E.T. Allen as the first state forester. The state forester sought help by the counties for appointments of fire wardens. In 1908, of the 47 fire wardens in San Bernardino County, 27 were employed by the US Forest Service, 11 by San Bernardino County, 8 were voluntary fire wardens, and 1 was employed by the City of San Bernardino.

On December 5, 1921, the San Bernardino County Board of Supervisors approved an agreement with the California Division of Forestry to provide a state fire warden for San Bernardino County. In addition, the county approved $1,500 to fund a state fire crew, with the state paying any additional costs. In 1922, the state forester appointed Paul Q. Harvey as the state's first ranger in charge for San Bernardino County.

In 1928, funding under a contract with the US Forest Service provided four patrolmen for the Santa Ana Canyon region. The following year, on June 10, 1929, the San Bernardino County supervisors signed an agreement with the California Division of Forestry relative to appropriation for the protection of watershed within San Bernardino County. On August 1, 1930, an agreement was made by the San Bernardino County Board of Supervisors with the California Department of Natural Resources for the protection from fire of watershed areas of San Bernardino County, thus beginning a nearly 70-year cooperative agreement with the California Division of Forestry, now known as CAL FIRE.

DEED FROM THE HESPERIA LAND AND WATER COMPANY.

This indenture, made this sixteenth day of August, 1888, between the Hesperia Land and Water Company, a corporation, party of the first part, and the State of California for the State Board of Forestry, party of the second part,

Witnesseth: That said first party, for and in consideration of the sum of ———— dollars, the receipt whereof is hereby acknowledged, hereby grants to said second party all of that tract, lot, or parcel of land in San Bernardino County, California, described as follows, to wit:

Block two hundred and two (202), containing twenty-one and fifty-two one hundredths (21.52) acres. Together with the right to the use of water thereon at the rate of one miner's inch, State measure, to each fifteen (15) acres, subject to the company's charges, as shown by the map and survey of Hesperia, in San Bernardino County, California, made by said first parties, to revert to the grantors whenever said second party shall cease to use said land for experimental forestry.

To have and to hold, subject to the following covenant, running with the land, to wit: It is provided, with a covenant running with the land, that if at any time said purchaser, their heirs, assigns, or successors in interest, or those holding or claiming thereunder, shall, with the knowledge or consent of the owner of said premises, use, or cause to be used, or shall allow or authorize in any manner, directly or indirectly, said premises, or any part thereof, or the street in front or along said premises, to be used for the purpose of vending intoxicating liquors for drinking purposes, whether said vending shall be directly or under some evasive guise, thereupon the title hereby granted shall revert to and be vested in the grantors herein, or their successors, or in any corporation to which they may grant said reversion; and they or their successors, or such corporation, shall be entitled to the immediate possession thereof; provided, that any bona fide mortgagee of said premises, in case the foregoing covenant be broken, shall have the option to at once claim and enforce the violation thereof; otherwise the foregoing covenant shall have the same force and effect as if said proviso was not herein inserted. In the dedication of the streets and alleys in said town to public use, there is hereby reserved from such use the right to vend or otherwise dispose of intoxicating liquors for drinking purposes, and to that extent said streets are, and hereby and forever shall remain, the private property of said grantors or their assigns.

Reserving to said first party the right to lay water pipes across said land, the same to be at least two feet below the surface.

In witness whereof, said first party has caused this indenture to be executed in the name of said corporation.

(Seal.) THE HESPERIA LAND AND WATER CO.
 R. M. WIDNEY, President.
(Seal.) S. H. MOTT, Secretary.
Subscribing witness: E. E. NOLD.

In August 1888, the Hesperia Land and Water Company donated 20.5 acres in Block 202 near the Santa Fe tracks and Mojave Street to the California State Board of Forestry. In October 1888, the Forestry Experimental Station would soon offer information as to what trees did best in different climate zones. The land was to be used as a nursery to grow native trees for reforestation of burned-over watershed.

SAN BERNARDINO, October 31, 1888.

To the State Board of Forestry:

GENTLEMEN: Your favor at hand. I would say to the State Board of Forestry that I have done all in my power to keep down fires, and I have succeeded in keeping sheep off of the most of the State and Government land in and about Bear Valley, one of the finest timbered and watered districts in the mountains, by placing friends of mine on timber claims in various places through the mountains, so that sheep could not get in without infringing on their claims, and by so doing have kept the mountains almost free of fires, as the sheep men are the cause of nine tenths of the fires in the mountains.

During the summer I have posted about fifty fire notices throughout my district, and as there has not been a fire this summer and fall that has done any damage, I judge by this that the fire notices have done the business. I watched very close this fall to try and catch some party setting out fires, to make an example of, but I could not do it, as there was none set out. Last fall a year ago the mountains were afire in every direction, which shows that the work has done some good.

Hoping that the above will be satisfactory,
Yours truly,

GUS. KNIGHT, JR.,
Special Agent State Board of Forestry.

August "Gus" Knight Jr., in a letter to the California State Board of Forestry dated October 31, 1888, describes his efforts to protect the San Bernardino forests from the destruction of fire. Knight had been appointed as a forest officer by the California State Board of Forestry in January 1888.

In May 1906, the San Bernardino County Board of Supervisors authorized supervisors of each supervisory district to designate the number of fire wardens necessary within each district for approval and authorization by the state forester. Each supervisor was authorized to appoint one fire warden for each district. Each fire warden received $3 a day for actual services rendered.

State Forester Names County Fire Wardens

As authorized by law (Stat. 1905, 295), the State Forester has appointed the following fire wardens, thus conferring upon them the powers of peace officers, to make arrests without warrant, for violations of any State or Federal forest laws; to compel the assistance in putting out fires, of any able-bodied citizen between the ages of sixteen and fifty years, and to grant or refuse burning permits, without which it is unlawful to burn brush, etc., during a dry season.

Any person having evidence against violators of the fire laws will render an important public service by placing it in the hands of the nearest fire warden or lodging it with the State Forester. Applications for permits to burn brush, stumps, logs, fallen timber, fallows, grass or forest-covered land, should be made to the nearest fire warden, as shown in the following list:

San Bernardino County Wardens.
Alen, Geo. H., Ioamosa.
Allen, J. H. B., Mentone.
Anderson, Lewis H., Upland.
Alverson, J. E., San Bernardino.
Bristol, W. M. East Highlands.
Brown, Albert C., Rialto.
Bidgood, C. L., San Bernardino.
Bannister, L. O., Upland.
Caley, W. S., Cajon.
Chandler, O., Fredalba.
Culver, F. C., Forest Home, via Redlands.
Crane, C. H., Redlands.
Dallas, A. P., Bryn Mawr.
Driscoll, J. A., Fredalba.
Dorr, Frank B., Redlands.
Easton, H. T., Highland.
Fuller, E. P., Upland.
Hun, A. M., San Bernardino.
Hamilton, C. B., Colton.
Harmon, James, Rialto.
Holt, G. W., San Bernardino.
Hostetler, Roy C., Redlands.
Jeken, F. J., San Bernardino.
Johnson, J. P., Mentone.
Keller, Ally C., Mentone.
Ledig, H. C., Ioamosa.
Lientz, B. P., Cajon.
McGregor, J. D., Highland.
Merrifield, E. C., Colton.
Moore, Thomas, San Bernardino.

Meyer, A. R., Fredalba.
Moya, M. F., Mentone.
Pine, Myron, San Bernardino.
Pease, Maurice L., Hesperia.
Price, O. H., Etiwanda.
Reese, W. R., Craftonville.
Stricby, Jos. J., Cucamonga.
Switzer, W. B., Fredalba.
Thomasson, Geo. W., Fredalba.
Thompson, George, Highland.
Walker, Thos., Highland.

Pay of Wardens.
Since the law authorizing the appointment of fire wardens makes no appropriation from which they can be paid, the majority of these men are either serving voluntarily or are paid by their employers. The remainder are paid, for services actually rendered in preventing or extinguishing fires, by the county in which the fire occurs. This is the case in the following counties of which the Supervisors have taken advantage of the amendment to the County Government act (Stat. 1905, 394) which permits them to appropriate from the general fund of the county for the purpose: Fresno, Kern, Los Angeles, Riverside, San Bernardino, Santa Clara, Santa Cruz, San Diego, Tuolumne, Tulare.

The Supervisors of these counties have appropriated sums ranging from $500 to $1500 for fire protection and have either increased the salary of the game warden and made him chief fire warden, with emergency fire wardens, who are paid for services actually rendered, or have depended entirely upon the latter. Either system is good so long as there are men distributed throughout the county who are paid to prevent and extinguish fires, and speaks well for the progressive spirit of the counties that have accepted this duty. The State Forester invites proposals from county governments, corporations and individuals for co-operation under these laws.

Circulars containing the forest laws and fire warning notices for posting will be mailed free to any address on application to G. B. Lull, State Forester, Sacramento, Cal.

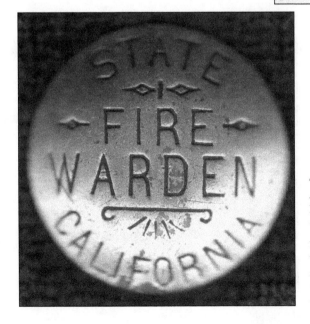

This was the first badge issued to the paid state fire wardens appointed by the state forester of the California Division of Forestry. This was issued from 1905 to the 1920s. There were two types of fire wardens, state and volunteer, that were approved by the sate forester and the California State Board of Forestry.

A citizen must respond to the call of a fire warden, to aid in fighting a fire, refusal being a misdemeanor. The following is the list of fire wardens for this county:

Alen, George H.—Ioamosa.
Allen, J. H. B.—Mentone.
Anderson, L. H.—Upland.
Awl, E.—Incline.
Babbitt, W.—Cajon.
Bannister, L. O.—Upland.
Bidgood, C. L.—San Bernardino.
Bristol, W. M.—East Highland.
Brown, Albert C.—Rialto.
Chandler, O.—Fredalba.
Codd, W. H.—Yucaipe, via Redlands.
Culver, F. C.—Forest Home, via Redlands.
Dallas, A. P.—Brynmawr.
Driscoll, J. A.—Fredalba.
Easton, H. T.—Highland.
Fuller, E. P.—Upland.
Stephens, George S.—San Bernardino.
Hamilton, C. B.—Colton.
Hancock, Foster—San Bernardino.
Hargrave, P. K.—Incline.
Harmon, James—Rialto.
Holt, G. W.—San Bernardino.
Hostetler, Roy C.—Redlands.
Howland, W.—Redlands.
Jeken, F. J.—San Bernardino.
Johnson, J. P.—Mentone.
Keller, Ally C.—Mentone.
Kenney, Benjamin—Hesperia.
Ledig, H. C.—Ioamosa.
Magill, C. M.—Redlands.
McGregor, J. D.—Highland.
Merrifield, E. C.—Colton.
Meyer, A. R.—Fredalba.
Moore, Thomas—San Bernardino.
Moya, M. F.—San Bernardino.
Pine, Myron—San Bernardino.
Pease, Maurice L.—Hesperia.
Price, O. H.—Etiwanda.
Reese, W. R.—Craftonville.
Strieby, Joseph J.—Cucamonga.
Switzer, W. B.—Fredalba.
Thomason, George W.—Fredalba.
Thompson, G. S.—Highland.
Thrall, H. A.—Mentone.
Walker, T.—Highland.
Waters, B. Jr.—San Bernardino.
Wixom, A. H.—Highland.

In June 1909, a new list of San Bernardino County fire wardens was announced. Fire wardens were authorized by the board of supervisors to hire assistants in fighting fire at the rate of $2 per day. People were reminded that a citizen must respond to the call of a fire warden to aid in fighting a fire; refusal to do was considered a misdemeanor.

From 1905 through 1964, versions of this badge were issued to the voluntary fire wardens in California. In July 1922, it was reported that a bag containing State of California appointments and badges was stolen from the vehicle of P.Q. Harvey, state district ranger, while parked in front of a house on F Street in San Bernardino.

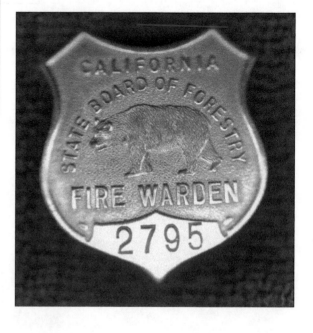

Here, the *1912 Handbook of Forest Protection* of the California State Board of Forestry lists the fire wardens for San Bernardino County. In the announcement of Victor Cherbak as fire warden to the Alta Loma District, the locals were reminded to contact Cherbak to obtain a permit and fix a date for his supervision prior to the burning of brushland.

CALIFORNIA STATE FIREWARDENS.

* Forest Service Officials. ‡ Fish and Game Officials.
† Paid County Officials.

SAN BERNARDINO COUNTY.

Alen, George H.*	Ioamosa
Allen, J. H. B.*	Mentone
Anderson, Lewis H.*	Care of Seven Oaks, Redlands
Brown, Albert C.*	Keen Brook
Butterfield, A. E.	East Highlands
Chandler, O.*	Fredalba
Cherbak, Victor A.	Ioamosa
Codd, Wm. H.	(via Redlands) Yucaipe
Console, D. A.	Colton
Culver, F. J.	(via Redlands), Forest Home
Dallas, A. P.	Brynmawr
Dewey, Wm. B.	Upland
Dexter, Geo. H.‡	San Bernardino
Duncan, Arthur	Cajon
Doughty, Ralph C.*	Arrowhead
Driskell, J. A.	Fredalba
Greenleaf, Lea	Upland
Hancock, Foster	1106 Ninth st., San Bernardino
Hardy, Chas P.*	Ontario
Hattery, L. O.	East Highlands
Higley, F. M.	Upland
Hill, Byron G.*	R. F. D., Upland
Howland, Winthrop	Redlands
Jeken, F. J.*	San Bernardino
Johnson, James P.*	Cajon
Knox, Donald G.	225 W. E st., Ontario
Ledig, H. G.†	Ioamosa
MacDonald, G. M.	Box 704, San Bernardino
McElfresh, O. H.*	Devore
Manley, Richard	Ontario
Meyer, Arthur R.	Care Wixon Bldg., San Bernardino
Moore, E. A.	28 W. State st., Redlands
Pierce, Wm.	R. F. D. No. 1, San Bernardino
Price, O. H.	Etiwanda
Showalter, John M.	Rialto
Stanchfield, J.*	Upland
Starke, Wm.	San Bernardino
Switzer, H. W.*	Fredalba
Thompson, Chas. O.	Box 113, Victorville
Thrall, H. A.*	Hesperia
Waters, Byron, Jr.	San Bernardino
Waters, Emmett J.	Devore
Williams, Thos.	Otis Station, Yermo
Wixon, A. H.*	Highland

Sec. 10. *Assistance of citizens in fighting fires.*—All fire wardens shall have authority to call upon able-bodied citizens between the ages of sixteen and fifty years, for assistance in putting out fires, and any such person who refuses to obey such summons, unless prevented by good and sufficient reasons, is guilty of a misdemeanor, and must be fined in a sum not less than fifteen dollars, nor more than fifty dollars, or imprisonment in the county jail of the county in which such conviction shall be had, not less than ten days, nor more than thirty days, or both such fine and imprisonment; provided, that no citizen shall be called upon to fight fire a total of more than five days in any one year.

Federal, state, and county forestry departments used general law No. 1216, section No. 10, allowing for the conscription of men for firefighting. In June 1906, fire warden George Uttman, of Etiwanda District, conscripted 17 men to fight fire in the Etiwanda area. Uttman was authorized to pay the men 25¢ an hour for services rendered.

The state forester appointed voluntary state fire wardens to serve in preventing and extinguishing fires in the local communities. Once the application was received with satisfactory recommendation, the appointment was made. Upon taking the oath of office, the fire warden was given a badge, a supply of fire-warning notices, fire report blanks, and copies of the handbooks of forest protection.

VALADEZ HEARING TO GO FORWARD

Arrest Redlands Man for Alleged Refusal to Fight Canyon Fire

(Special Staff Correspondence)

REDLANDS, Aug. 5.—Q. R. Harvey, fire warden, called at the office of Judge Peter G. McIver today, and stated the prosecution of Juan Valadez, who was arrested on a warrant sworn out by the fire warden, on July 28, will go forward.

Trial has been set for Aug. 11 at 10 o'clock, in Judge McIver's court.

The case arises out of a summons by the fire warden to Valadez, on the night of July 26, to fight a fire in Reche Canyon. Harvey has stated that Valadez refused the summons and induced other workmen to refused to work.

Valadez, at his preliminary before Judge McIver, on July 28, denied having refused to work, but said he demanded his pay before leaving for the fire, giving as reason for this that he had fought two other brush fires in the past and had been denied payment for the labor.

Harvey stated today, it is said, that under a law which was but recently repealed, men could be summoned without payment under certain conditions.

On August 6, 1922, one of the individuals who refused to come to the aid of the forestry ranger appeared in court. Very few citizens summoned to fight fire ever challenged the authority of the forest rangers or fire wardens. Only a few arrests were ever reported. (Courtesy of San Bernardino County Archives.)

In June 1922, Paul Q. Harvey was appointed state district ranger to San Bernardino County, formerly from San Diego. At the regular meeting of the San Bernardino County Board of Supervisors, an agreement was signed with the California State Board of Forestry for a state fire warden and maintenance of a state fire crew for San Bernardino County. The agreement lasted one year due to downsizing of the state budget under Gov. Friend Richardson.

In September 1925, the San Bernardino County Board of Supervisors appointed Roy M. Tuttle, formerly of the San Bernardino National Forest, Skyland District, as county fire warden to patrol the areas outside of the national forest. Tuttle's appointment, originally for the months of fire season, was retained for the entire year in November 1925. In May 1926, Tuttle was appointed district state fire ranger by state forester M.B. Pratt, and in July, he became Little Mountain Lookout Tower's first watchman. In January 1929, upon accepting employment as chief of the Forestry and Fire Protection Division of the Los Angeles County Recreation Camp in Big Pines near Wrightwood, Tuttle announced his resignation as fire warden. This photograph was taken in 1955 on his retirement from Los Angeles County Big Pines Park.

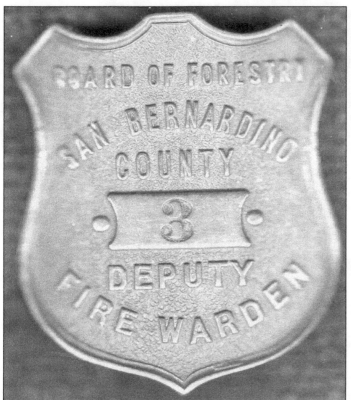

In May 1926, county forester Roy M. Tuttle received 25 new badges, which were to be given to deputy fire wardens. The badges were in the form of bronze shields and were numbered. They bore the wording "Board of Forestry San Bernardino County Deputy Fire Warden." The badges were issued to the fire wardens assigned to the 15 districts that the county forestry department was divided into.

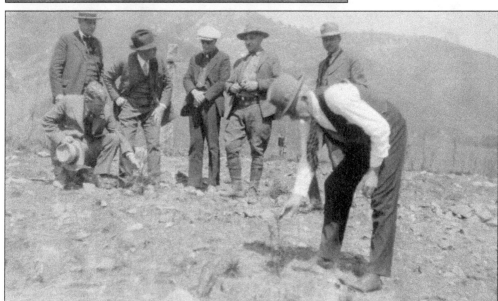

State forester Merritt Pratt, county forester Roy M. Tuttle, and members of the San Bernardino County Board of Forestry examine new seedlings at the Devils Canyon Nursery, operated by the US Forest Service. Early talks of the nursery started in August 1926 when state forester M.B. Pratt, extension forester Woodbridge Metcalf, and J.G. Peters, in charge of federal funds under the Clarke-McNary Act, met with the San Bernardino County Board of Forestry.

Little Mountain Lookout Tower was officially opened on July 2, 1926, by the San Bernardino County Forestry Department. From left to right are lookout Joseph Page, county forester Roy M. Tuttle, state forester Merritt Pratt, and J.G. Peters. Peters was in charge of federal funds under the Clarke-McNary Act.

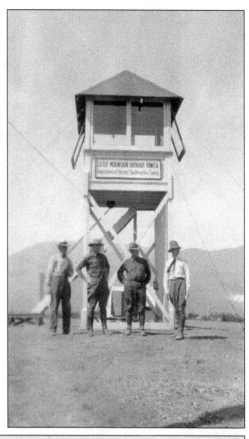

Here, a deputy fire warden patrols the mountain roads of San Bernardino County. In 1928, seven county fire rangers were appointed to patrol the county forest areas outside of the national forest. These seven rangers and patrol areas were R.A. Mead, Carbon Canyon District; W.S. Musselman, San Antonio Canyon; R.E. Price, Etiwanda Canyon; Leslie McDonald, Lone Pine Canyon; Richard Jackson, Oak Glen; and Ed Guthrie, Wildwood Canyon on weekends and holidays.

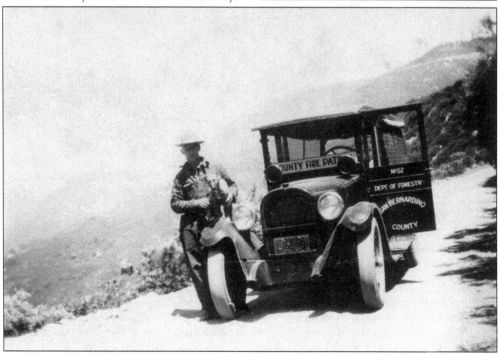

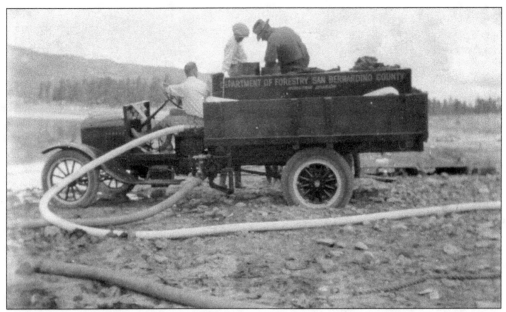

In June 1928, this fire truck was placed at a Bear Valley resort. It had a capacity of 300 gallons and a pump and hose. It was used on the Brown sawmill fire in July 1928, where its use reportedly saved 35,000 board feet of lumber.

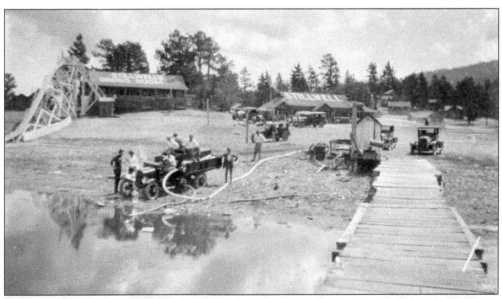

San Bernardino Division of Forestry mountain division fire wardens train with their new equipment at Big Bear Lake. In July 1927, an additional fire truck, purchased by the county board of supervisors for San Bernardino, was placed in service. It was kept during the day at the county courthouse, and at night, it was stored at the county garage on Sixth Street and Sierra Way.

Two

COMMUNITY-BASED COOPERATIVE AGREEMENTS

CAL FIRE, through its cooperative agreement with San Bernardino County, established community-based fire protection throughout San Bernardino County. Valley, mountain, and desert communities contracted through the county agreement with the California Department of Forestry (CDF) or would have community-based fire protection established utilizing paid-on-call firefighters or a combination of paid CAL FIRE personnel and paid-on-call support.

Over the years, communities such as Bloomington, Crest Forest, Wrightwood, Fawnskin, Morongo Valley, and Joshua Tree had CAL FIRE personnel providing fire protection. Communities outside of self-governed special districts fell under the board-governed County Service Area No. 38 (CSA-38) District. These areas were Yucaipa, Highland, Phelan, Spring Valley Lake, Mentone, Grand Terrace, and many other desert communities.

With the cancelation of the cooperative agreement by the San Bernardino County Board of Supervisors in 1998, many of these communities fell under the protection of the San Bernardino County Consolidated Fire Districts, doing business as the San Bernardino County Fire Department. However, two cities, Highland and Yucaipa, elected to establish their own fire departments and directly contract with CAL FIRE.

George Park accepted the position of state ranger in charge of San Bernardino County under the first cooperative agreement between the California Division of Forestry and San Bernardino County on August 1, 1930. Park started his career in forestry with the US Forest Service as district ranger in the Cleveland National Forest in 1912. In 1927, he accepted a position as assistant county forester with San Bernardino County under Roy M. Tuttle. Park resigned from his position as state ranger in charge on October 1, 1930.

Arthur T. Shay accepted the position of state ranger in charge for San Bernardino County in October 1930. Shay started his forestry career with the US Forest Service on August 1, 1913, at Hook Creek Camp near Lake Arrowhead and was promoted to assistant forest supervisor. After a monthlong illness, Art Shay died on May 9, 1931, while serving as state ranger in charge for San Bernardino County. At the time this picture was taken, he was employed by the San Bernardino National Forest. He is wearing two badges: on the left is his forest service badge, and on the right is a state voluntary fire warden badge.

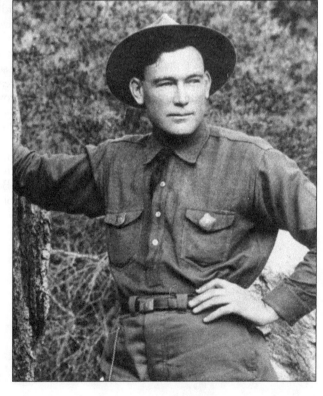

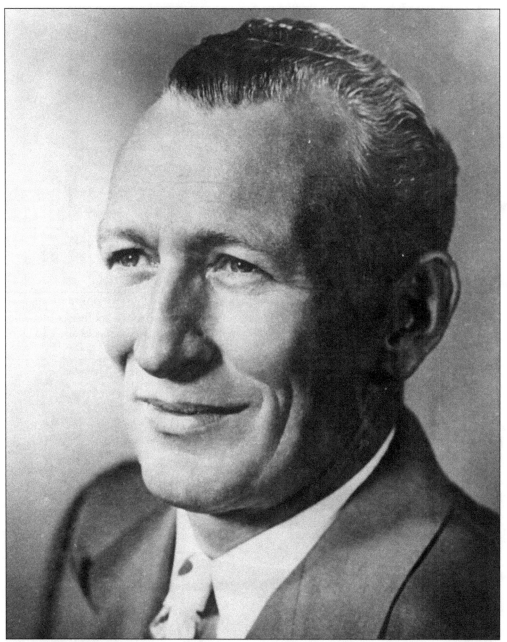

Russell Z. Smith started with forestry around 1929 and was appointed to the position of state ranger in charge in May 1931 after the death of Art Shay. Smith was appointed chairman of the county fire prevention committee and the aircraft warning service of the county defense council. In May 1942, he was inducted into the Army as captain and was ultimately promoted to major. After the war, he was unanimously appointed by the San Bernardino Orange Show Commission as general manager of the San Bernardino National Orange Show. On February 21, 1952, while returning from the Riverside County Fair and Date Festival, Smith was killed in a traffic collision on Highway 111.

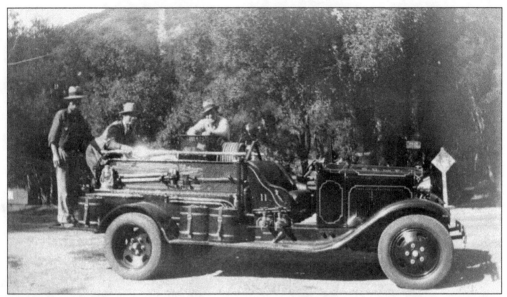

On June 6, 1931, the California Division of Forestry bought pumper No. 11, a 200-gallon pumper. On June 19, 1931, after having been publicized as the state forestry chief for all Southern California, Jesse Graves announced that San Bernardino was in line for two more fire trucks and two more drivers arriving in August.

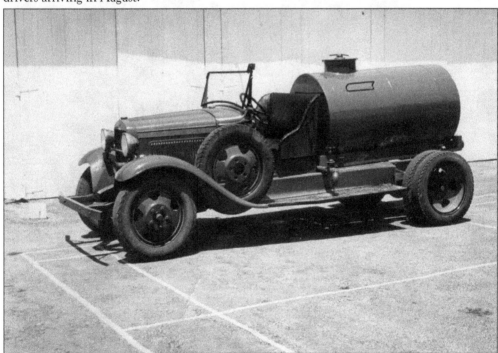

This 1930 Model A tanker was fabricated at the shop at San Bernardino Headquarters and used primarily to water trees and to back up engines. It had a Briggs and Stratton engine and pump at the back of tank. In March 1931, the state forestry truck was used to water trees planted along Kendall Parkway on the north side of Little Mountain in San Bernardino. This engine also provided support to the Santa Fe Railroad with the burning of brush along the tracks.

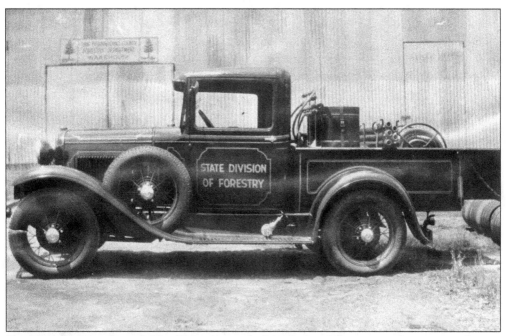

State forestry patrol truck No. 32 is seen parked in front of the county forestry warehouse, located on Sierra Way and Sixth Street in San Bernardino. Prior to the construction of forestry headquarters at 3870 Sierra Way in 1937, two fire trucks were stored at the Sixth Street location, and the crew members were called from their homes to man the truck.

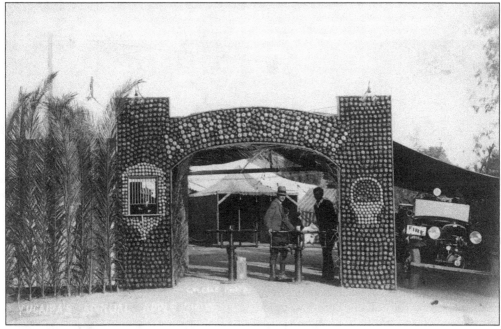

A state forestry truck is seen on standby at the Yucaipa Apple Festival from October 20–25, 1931. As guests go under the decorative arch, they walked by the new fire truck assigned to Yucaipa Valley. The apparatus, under the control of E.P. Guthrie, justified it presence by saving the tent and exhibits from major damage by fire on Friday of that festival.

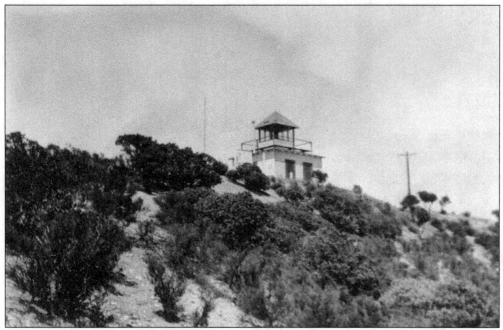

The Summit Lookout Station was located just above today's brake-check stop at the summit of Interstate 15 at the top of Cajon Pass. On October 20, 1931, Jesse Graves, state forestry chief, stated that a road was to be built from this point eastward toward Summit Railway station, thus making a connection with Horsethief Canyon.

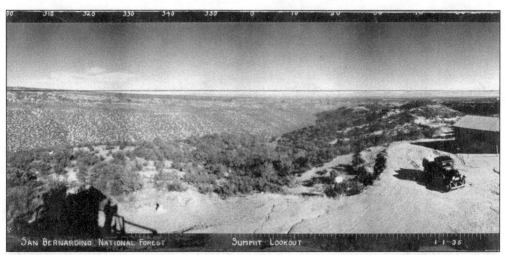

On June 12, 1932, San Bernardino State Forestry officials announced that a fire truck would be maintained at the Summit Lookout Station. In August 1964, tower watchman Elmer Seniff spotted smoke to the north from an unreported structure fire near Main and Mojave Streets in Hesperia. The fire truck at the Summit Lookout Station was later moved to Hesperia. "Seen area" photographs like this were taken by the US Forest Service from different lookout points and were used to determine the optimal area of visual coverage for each lookout. (Courtesy of Bud Parrot.)

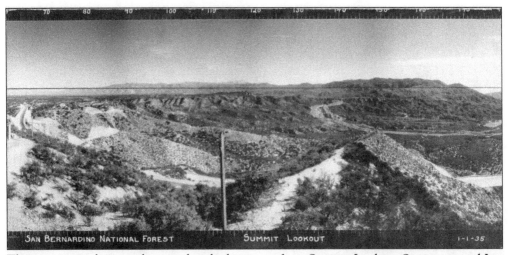

This seen area photograph was taken looking east from Summit Lookout Station toward Los Flores Ranch and Miller Canyon. A fire starting on August 8, 1936, east of the highway near Summit Valley was battled by the Civilian Conservation Corps (CCC) crews from Lytle Creek, Miller Canyon, and Mill Creek Camps. Crews of the state forestry service assisted. The fire was declared out two days later.

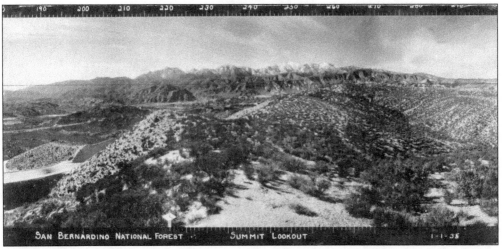

This was the view from Summit Lookout Station facing west toward Mount Baldy and the community of Phelan. In 1931, a telephone line was constructed from the ranger station in Cajon Pass to the Summit Lookout Station. The line was to support the state forestry station at Summit Lookout. A portion of $1,200 was used for the construction of the phone line.

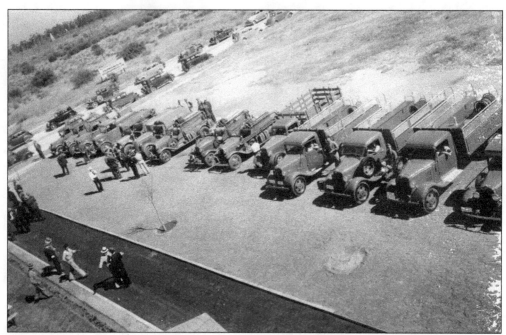

The California Division of Forestry dedicated the newly constructed facilities at 3870 Sierra Way as ranger unit headquarters. Crews and equipment from the US Forest Service, Crest Forest Fire District, and surrounding departments participated. The local Works Progress Administration (WPA) band played the "Star Spangled Banner," followed by children from Arrowhead Elementary school singing "My Country, 'Tis of Thee."

The equipment belonging to San Bernardino Headquarters of California Division of Forestry included, from left to right, a 1937 Dodge with Chris Donkle in the cab, a 1936 Ford with Al Cherbak in cab, a 1936 Dodge with Barney Long (rear) and Ed Young (Smokey Hat), and a 1936 Mack with Jack Burke in the cab. This photograph was taken in 1938 in front of the newly constructed truck garage.

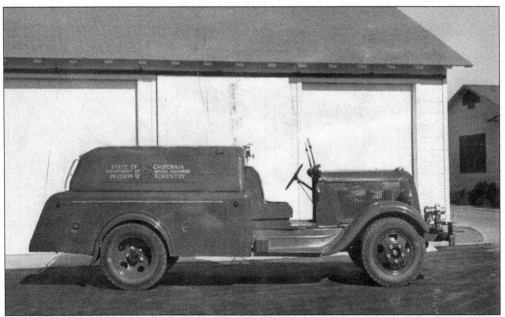

This 1937 Mack truck, pumper No. 6, was fabricated at the San Bernardino forestry equipment shop and placed in service on May 21, 1938. The San Bernardino District of the California Division of Forestry covered all areas outside of the national forest west of Orange Street in Redlands to Lytle Creek. Equipment in 1933 included a Moreland fire truck, a Chevrolet patrol truck, and a Ford utility tank truck.

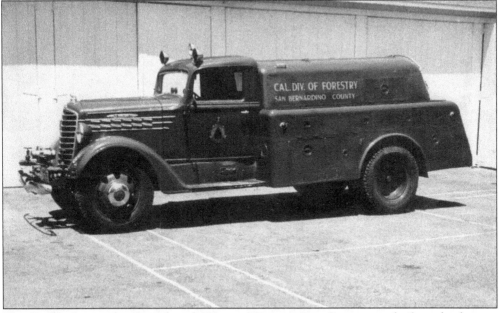

This Dodge fire truck assigned to the Yucaipa Forestry Fire Station was built at the forestry equipment shop in San Bernardino. In 1933, the Yucaipa District included all lands outside of the national forest east of Orange Street in Redlands south to the county line. District personnel included one truck driver, a patrolman, and one suppression crewman. The equipment included a Ford fire truck and a Chevrolet patrol truck.

Alta Loma Forestry Fire Station was built in 1937 on land donated by the Alta Loma Vineyard Company. The station was located on Highland Avenue east of Haven Avenue. On May 3, 1954, the San Bernardino County Board of Supervisors granted a quitclaim deed to L. Bar S. Ranch for property no longer needed, having relocated to the Etiwanda Forestry Fire Station.

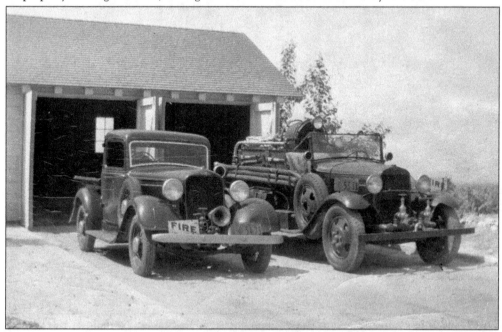

Patrol No. 4 and pumper No. 31 were assigned to the Alta Loma Forestry Fire Station. In May 1937, assistant ranger Larry Shay opened the station with a crew of seven men. In May 1936, construction of state forestry stations was funded through a $100,000 expansion program. The San Bernardino Headquarters and stations in Alta Loma and Yucaipa had similar designs.

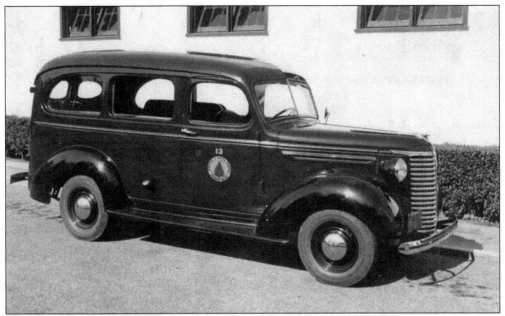

Here is one of the California Division of Forestry trucks equipped with receivers, which allowed the rangers to communicate with fire crews. In April 1938, two automobiles and four trucks were equipped with receivers to communicate and direct the ranger's staff in fire suppression work. The equipment was reportedly used with 100-percent satisfactory results.

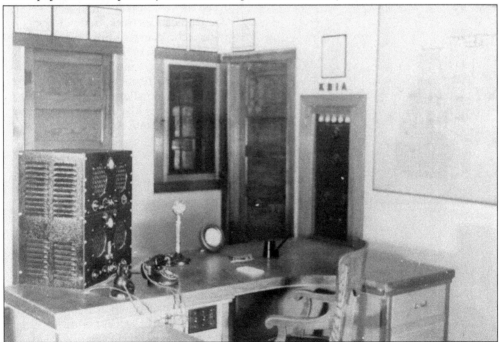

Through the cooperation of the county's radio station KSBC, located in the San Bernardino Courthouse, a remote radio station was set up at the California Division of Forestry's district office at 3870 Sierra Way in April 1938. This allowed for direct communication from forestry headquarters to the cars and trucks in the field.

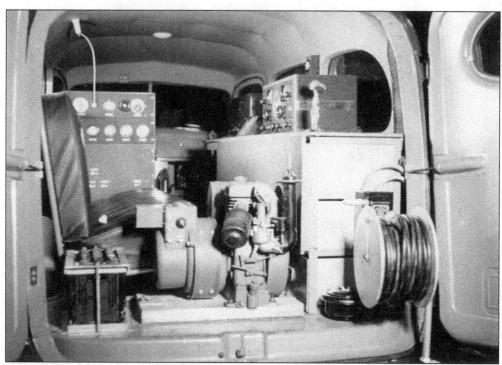

When the radio equipment and receivers were installed inside the communications truck, Carl Anderson, radio technician for KSBC, supervised the installation of the remote radio equipment. State ranger Smith stated that the department would have invested over $1,500 in radio apparatus to aid in fighting fires by May 1939. (Courtesy of California State Archives.)

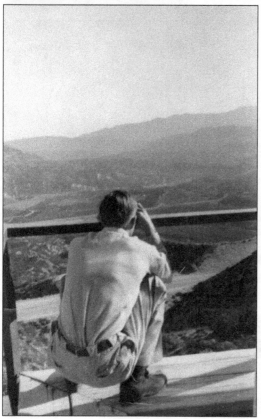

Forestry lookout George Meers scans Cajon Pass for brushfires from the Summit Lookout Station. Many fires resulted from the exhaust or the brakes of trains. In August 1939, Meers observed what appeared to be Aurora Borealis in the northern sky. The same thing was seen by many others in the San Bernardino Mountains.

Little Mountain Lookout is seen here in 1938. In 1927, a porch was constructed on which the observer could use a heliograph. The heliograph was installed to communicate with work crews and Keller Peak Lookout Tower. A residence was built for the observer in 1928. Prior to the construction of the residence, lookout man Milton Jackson lived in a tent.

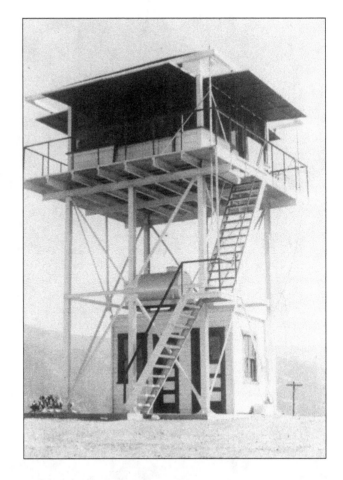

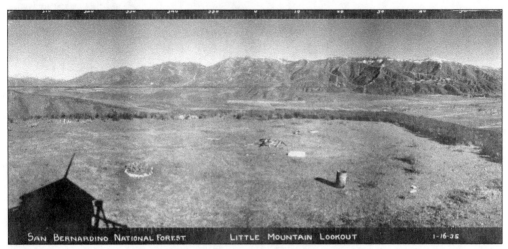

On November 24, 1938, the watchmen from Little Mountain Lookout had a direct view of the 9,000-acre Arrowhead fire and the destruction of the Arrowhead Springs Hotel, located on Old Waterman Canyon Road off Highway 18. (Courtesy of Bud Parrot.)

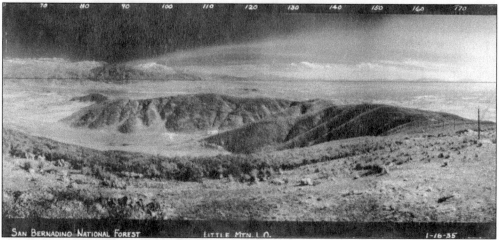

County fire warden Tuttle asserted that the lookout covered a good portion of Mill Creek and up into Oak Glen, Pine Bench, and Crafton Hills. The lookout's view east in 1935 covered the expansion of San Bernardino City into the citrus groves. In 1931, San Bernardino County state forest ranger Russel Smith announced plans for a new primary lookout tower for San Bernardino County near the community of Yucaipa. On hazy days, the Little Mountain Lookout was handicapped with poor visibility. (Courtesy of Bud Parrot.)

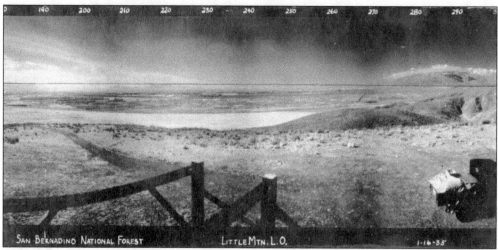

Looking due west from the Little Mountain Lookout Tower, Milton Jackson reported fires in the front country area of Rialto, Fontana, Cucamonga, Alta Loma, Upland, and the Chino Hills. On July 7, 1930, a fire along the Santa Fe tracks was brought under control by Ray Moore, of Devore Forestry Station, and ranger in charge Russell Smith after it was spotted from the Little Mountain Lookout. In March 1967, due to budget cuts and development in the area, the closure of Little Mountain Lookout was recommended. (Courtesy of Bud Parrot.)

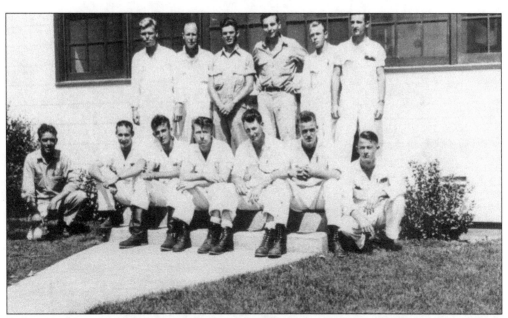

A few members of the 1938 San Bernardino Headquarters crew are pictured here. Among them are Jack Burke (sitting second from right), suppression crew foreman Ed Young (standing third from left), Bob Moran, and Don Ashley. In 1940, Moran and James Fenlon were the operators of the two state forestry trucks from headquarters. Moran worked at San Bernardino Headquarters through 1947, reaching the rank of assistant ranger.

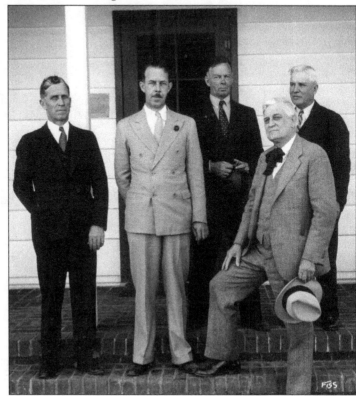

Attending the April 1937 dedication of San Bernardino State Forestry headquarters are, from left to right, Walter Coupe, Sacramento deputy state forester; Ralph Smith, district director of the WPA; Herbert Gilman, state board of forestry; Dr. J.N. Baylis, San Bernardino county board of forestry; and Arthur Doran, San Bernardino county board of supervisors. The keynote of the ceremony, "cooperation," was emphasized by Walter Coupe: "A few years ago this was undreamed of. But it shows what can be accomplished by cooperative effort."

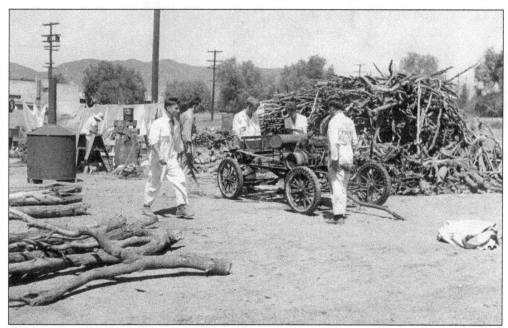

A 1939 woodcutting project at Yucaipa Station is seen here. Wood, gathered from firebreaks in the mountains above the Yucaipa community and from clogged streambeds resulting from the disastrous 1938 floods, was brought to the Yucaipa forestry station and cut for firewood. The CCC in Southern California built over 1,500 miles of forest roads and 900 miles of firebreaks.

The forestry fire station crew of San Bernardino Headquarters is pictured in 1939. Jack Burke, future San Bernardino unit ranger, is at center. A 15-man crew from San Bernardino Headquarters assisted in firefighting efforts near the Arrowhead Country Club area of Parkside Drive and Thirty-Fourth Street in San Bernardino. On June 28, the temperature in San Bernardino reached 101 degrees Fahrenheit at San Bernardino Headquarters.

Pictured in 1938 are, from left to right, assistant ranger in charge W.W. "Butch" Skinner, mechanic John Hansen, and ranger in charge Russell Smith. Hansen, prior to working with state forestry, was known in the area as an automobile service expert. In 1942, he served as an assistant to state forester Truman Holland in San Bernardino.

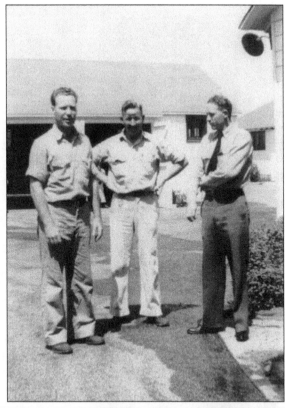

Pictured in front of San Bernardino Headquarters are, from left to right, (seated) Jeanette Burke, John Tomlin, Bob Moran, Jack Burke, and Don Ashley; (standing) W.W. "Butch" Skinner, Deloise Henderson, and D. Elsor. In October 1942, Deloise Henderson served as a captain in the San Bernardino County Women's Ambulance and Defense Corps.

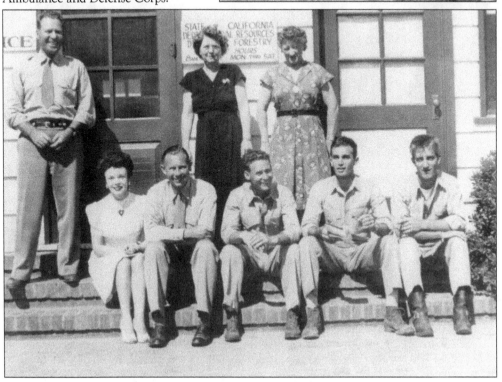

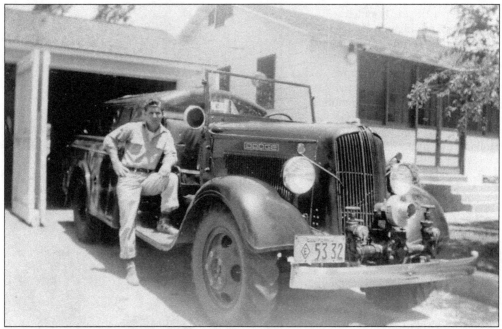

In 1942, Kaplan "Kap" Sharpe stands next to state forestry truck No. 6 assigned to Yucaipa. The garage was remodeled in 1948 to accommodate larger fire equipment. Sharpe entered the Navy on September 28, 1943. By July 1942, the enlistment of men in the armed forces had virtually eliminated potential sources of firefighters. (Courtesy of Yucaipa Valley Historical Society.)

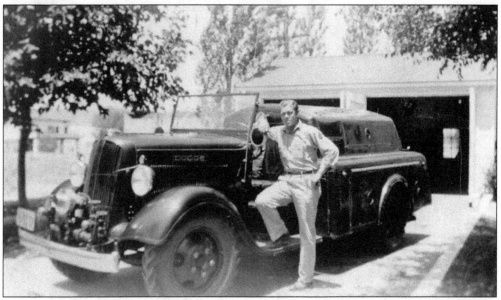

Swede Kheal was the truck operator at Yucaipa Station in 1942. The budget for the California Division of Forestry for 1942–1943 had been increased from $2 million to $6 million in order to protect agricultural areas and brushlands against natural fire hazards and possible sabotage by invaders. Warner L. Marsh, deputy director of the California Board of Forestry, announced that state forestry had approximately 200 new trucks, and an additional 1,000 men were available to the state for the 1942 fire season.

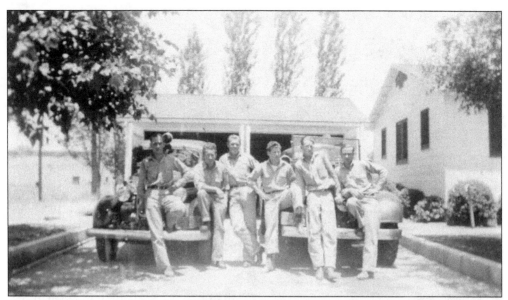

These 1942 Yucaipa firefighters are, from left to right, Levi Friend, Orville Matzkie, Swede Kheal, Kaplan Sharpe, Bob Renshaw, and Del Parcher. Yucaipa's state forestry station was built in January 1936. It was the first state forestry station built in San Bernardino County and is registered as a California Point of Historical Interest. (Courtesy of Yucaipa Valley Historical Society.)

Warner Lincoln Marsh, deputy director of the California Department of Natural Resources, is planting knobcone pines in City Creek Canyon. The knobcone pine seeds only spread after a fire opens the hearty pinecone. The knobcones of City Creek can be traced to T.P. Luvens, who worked as a government forester in 1892. (Courtesy of California State Archives.)

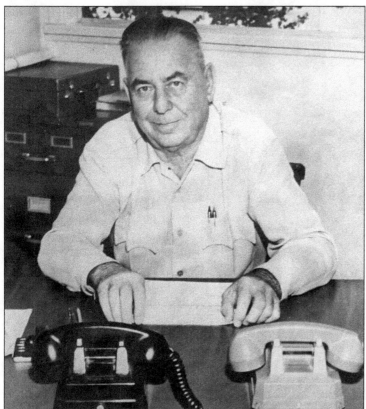

Truman Holland was assigned to San Bernardino Ranger Unit after W.W. Skinner's induction into the Army Air Corps in September 1942. Holland established forestry stations in Bloomington and Twentynine Palms during the war years. On April 1, 1946, Skinner returned from the service to his post as ranger in charge of San Bernardino. Holland was transferred to Riverside County.

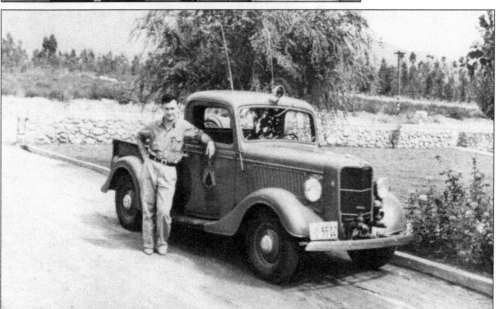

Larry Shay was assistant ranger of the Alta Loma District in San Bernardino County. Shay started with the California Division of Forestry in 1931, and in 1966, he received his 25-year award from the division of forestry. He was the son of Art Shay, who died in office as state ranger in charge of San Bernardino County in 1931.

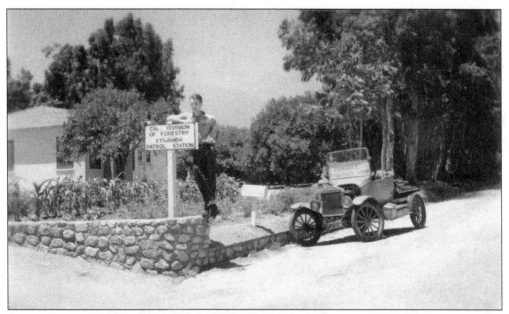

Pictured on June 7, 1942, is Etiwanda foreman Chuck Ulrey. On June 2, 1941, the San Bernardino County Board of Supervisors accepted a deed from the Etiwanda Domestic Water Association, located on Etiwanda Avenue south of Highland Avenue, for the use of the Etiwanda Forestry Station. At the time the station was constructed, it was surrounded by grape vineyards.

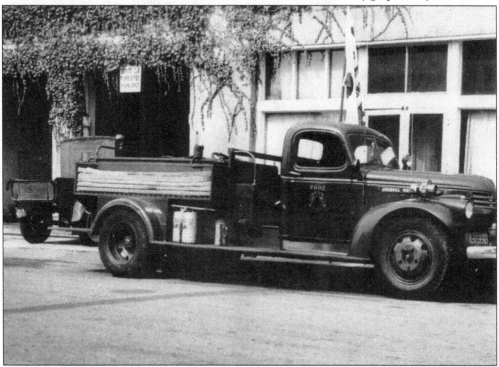

In May 1943, a second state forestry truck at the Highland Fire Station was staffed with a full-time driver, Martin Wissler. Clarence Abel was in charge of the station. The second truck had been there for some time and was previously staffed with volunteers trained to operate it.

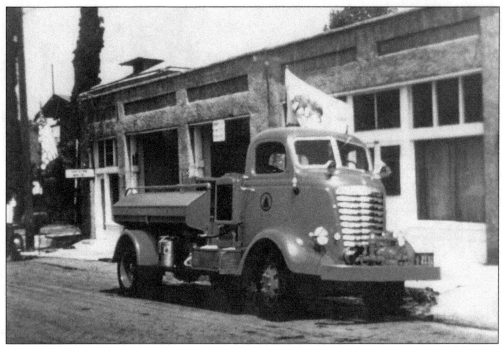

In July 1916, a new brick firehouse, located at the east end of the Linville block, was constructed by J.D. Baugh and F.H. Welton in the community of Highland. The Highland Forestry Fire Station, located in the Haygood Building on Pacific Street, was relocated to 27284 Main Street in October 1942. This location was used from 1942 to 1977. Rent in 1942 started at $15 a month, reaching $125 by 1977. Originally from Etiwanda, Engine 230 was reassigned to Highland in 1957.

In October 1938, the Mentone Chamber of Commerce promised the community it would have a fire station located near "Rocky Comfort," and a site was selected near Tyler's store. In March 1943, San Bernardino County purchased the rock building on the northeast corner of Mentone Boulevard and Crafton Avenue from the Gabriel Basor estate, and it was used as the Mentone Forestry Fire Station. In 1922, fire apparatus was available at the Mentone Post Office.

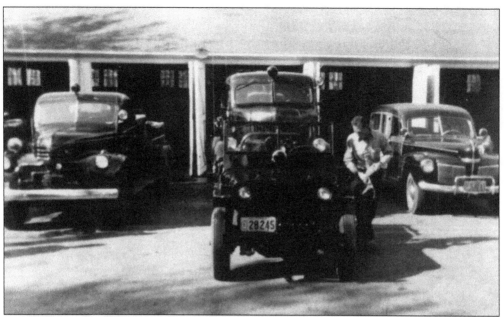

Howard LaPlante is pictured at the engine garage of San Bernardino Division of Forestry Headquarters in 1947. In November 1947, LaPlante was one of two engine foremen assigned to San Bernardino Forestry Headquarters. Others assigned to San Bernardino forestry at that time were Bart Myers, a newly appointed assistant ranger, and Chuck Ulrey, an assistant ranger in the west end district with offices at San Antonio Heights Forestry Fire Station.

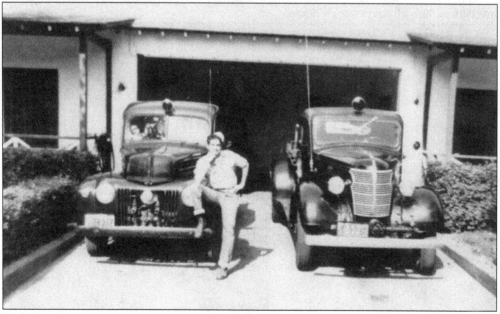

Dick Ouster is seen at Loma Linda Forestry Fire Station in 1947 with engines Nos. 244 and 215. On July 2, 1947, San Bernardino County State Forestry crews from Loma Linda, Mentone, and Yucaipa battled a 300-acre fire near the Charles Lines Ranch in San Timoteo Canyon southwest of Redlands. Crews were pulled off the fire to battle another fire near Crystal Springs, a quarter mile east of Redlands along Highway 99, holding it to five acres.

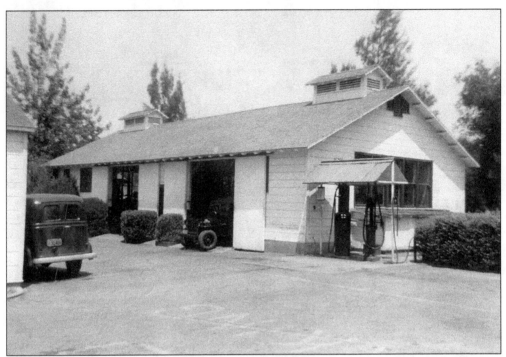

A combination gashouse and equipment garage for the division of forestry for San Bernardino County was constructed in 1937. This building was remodeled in May 1982 to accommodate a California Department of Forestry emergency dispatch center. In 1973, a larger automotive shop was built along with a separate gashouse.

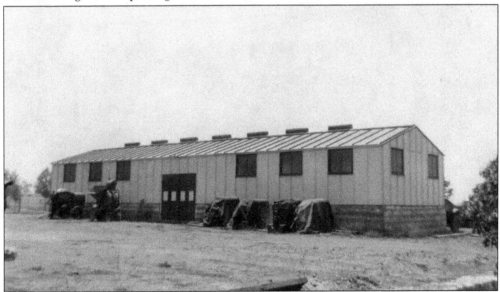

Pictured is one of the two warehouses constructed in 1937. This building was used by District No. 6. In 1937, District No. 6 included the counties of San Diego, Riverside, Orange, San Bernardino, Los Angeles, and Ventura. In 1977, an 11,000-square-foot metal building was finished, providing needed storage space for the San Bernardino County Fire Department and California Department of Forestry cooperative agreement.

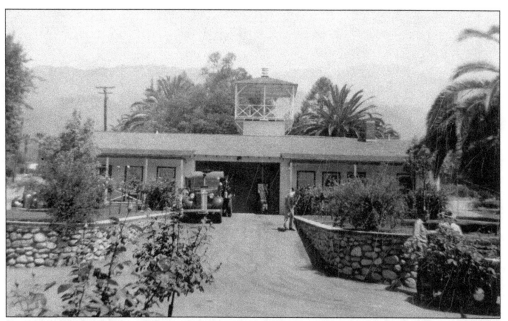

San Antonio Heights Forestry Fire Station was built in 1942 by San Bernardino County for the California Division of Forestry at a cost of $6,156.26 with a no-cost lease. A local building material supplier offered the county sufficient marble for construction and land for a lookout tower; however, the county had already planned for station construction to be of reinforced concrete.

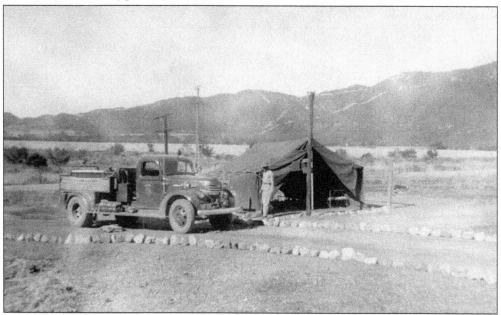

On May 7, 1941, land was deeded to the state forestry from Bank of America. From 1941 until construction of the current station in 1951, a tent was placed on the property. Devore Fire Suppression Station opened in July 1948. With San Bernardino County's appropriation of state forestry funds for 1941, fire protection for the Cajon Pass District and the north Fontana area near the airport used by Cal-Aero students could be served by the Devore station. (Courtesy of California State Archives.)

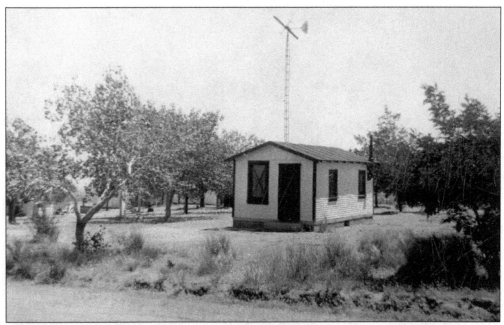

California Division of Forestry, San Bernardino County, rented this building in 1948, which was located near the southeast corner of Sheepcreek and Phelan Roads. It served as the Phelan Forestry Fire Station until 1954. Willis Adams, who had been the relief driver between Loma Linda and Highland, was reassigned to the Phelan Forestry Station. (Courtesy of California State Archives.)

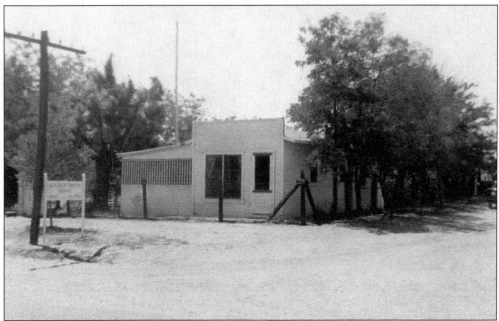

A residence was rented at the corner of Third and Main Streets in the community of Hesperia by the California Division of Forestry to house the crew out at the Summit Lookout. Previously, the Summit Lookout crew returned at night to the San Bernardino Forestry Headquarters to sleep and eat. This photograph was taken in July 1948. (Courtesy of California State Archives.)

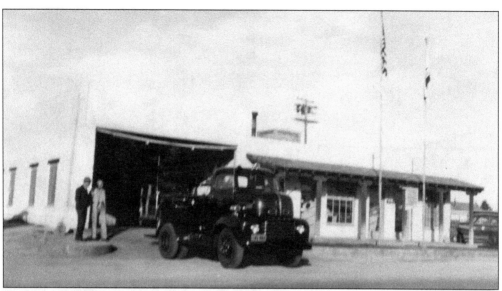

Twentynine Palms Forestry Fire Station is seen in 1950. On May 8, 1944, San Bernardino County supervisors approved a lease option for $10,000 for a term not to exceed 10 years with the Twentynine Palms Business Associates for the construction of a suitable fire station, living quarters, and offices. The Twentynine Palms Business Associates had previously donated lot No. 73, tract No. 2512.

Twentynine Palms forest fire foreman Ray Bolster, of the California Division of Forestry, is seen in 1950. Born July 27, 1892, Bolster drove a freight wagon in 1910 from Pasadena to Twentynine Palms, served in the US Marine Corps during World War I as a corporal, and worked with the California Division of Forestry in Twentynine Palms from 1944 until his retirement in 1957. Two of his sons, Richard and Walt, also made careers with the division of forestry.

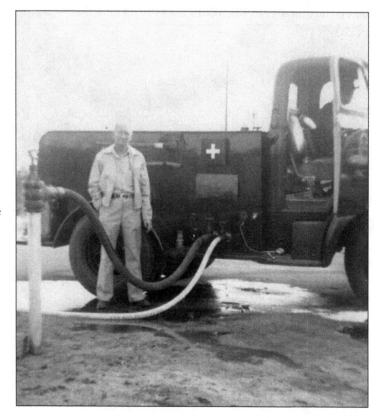

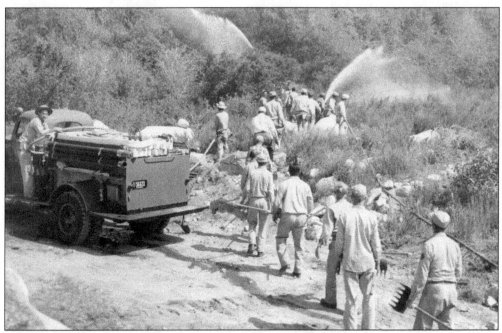

This three-day fire training school was conducted in Devils Canyon starting May 28, 1950. Over 40 firefighters from San Bernardino California Division of Forestry started their day at 5:00 a.m. at the mobile camp set up by the department in Devils Canyon. Organized by assistant ranger Chuck Ulrey, the training emphasized the use of hand tools, fire behavior, and line construction.

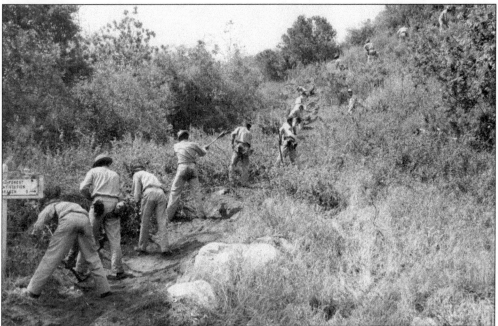

Forestry firefighters also demonstrated their skills in hand line construction, using shovels, McLeod rakes, pulaskis, and brush hooks. In 1950, chainsaws had not become a part of the wildland firefighter's inventory. The 40 firefighters were taken on a night march through the mountainous terrain in Devils Canyon below Crestline California.

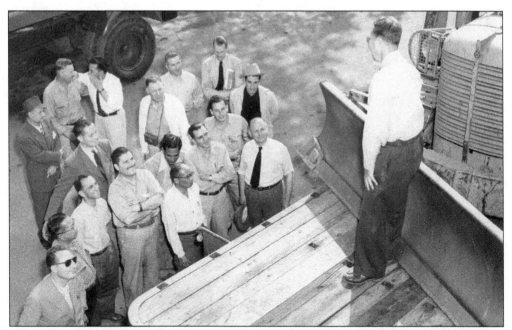

In October 1951, forestry officials from 13 foreign countries visited San Bernardino County. California Division of Forestry and San Bernardino Forest Service officials demonstrated the latest fire control techniques that had been developed in California. The group visiting San Bernardino included representatives from Argentina, Chile, Guatemala, India, Mexico, Pakistan, the Philippines, Thailand, Turkey, Venezuela, Greece, Turkey, and the Netherlands.

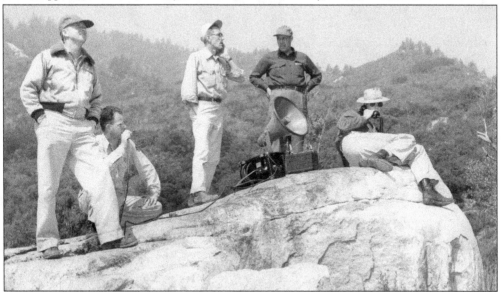

Overseeing the annual three-day training session of 1952, located in City Creek Canyon, are, from left to right, Chuck Ulrey, Howard LaPlante, Tom Bryan, an unidentified official from the San Bernardino National Forest, and Bob Shannon. The three-day school covered methods used to combat wildland fires, use and care of fire tools, and the use and general maintenance of pumpers. Second-day topics included tree falling, line construction, and law enforcement. Day three covered setting up pack stock, first aid, and public relations.

Devore Forestry Fire Station was constructed in 1951 at a cost of $21,250 on approximately one acre. Land was donated by Bank of America in 1941. In June, Gov. Culbert Olson signed a bill appropriating $105,404 for additional fire protection in Southern California. San Bernardino's appropriation provided funds for the Devore State Forestry Station, the purchase of a fire truck, and the employment of an assistant ranger.

Barracks and a garage were constructed for California Division of Forestry, San Bernardino County. In May 1951, work crews started on the foundation of the new building. When completed in 1953, the new facility provided housing for 16 firefighters. Just recently, the barracks building has been remodeled, adding a conference room and a small kitchen and dining area for firefighters.

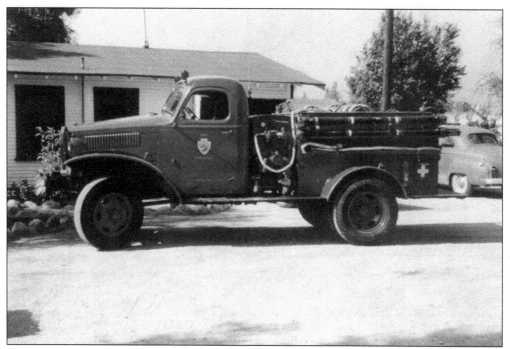

In 1954, this 1944 Jeep four-by-four fire truck and others like it were assigned to San Bernardino Headquarters. The military chassis were acquired through excess property and converted to fire trucks. The trucks were outfitted with a 400-gallon tank and a 350-gallons-per-minute auxiliary pump. All modifications were made in the San Bernardino shop by firefighters assigned there during winter months. Six of the fire trucks were converted and placed into service.

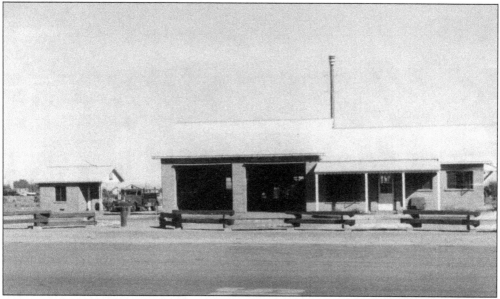

One year after the California Division of Forestry moved into its new station in Hesperia in 1954, a volunteer fire department was organized for the Hesperia community. A siren was installed at the forestry station, which was used by the volunteers as a meeting place until October 1957, when their own fire station was completed.

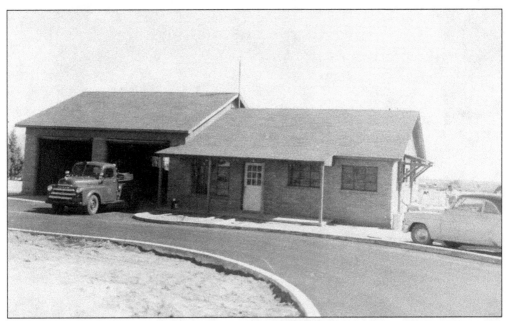

Phelan Forestry Fire Station was originally located at 9501 Sheep Creek Road. This station was built in 1954 at a cost of $17,247 using Millerton brick from the Fresno area. A cistern and pump house was also constructed behind the station for a cost of $2,300. The station was relocated to the corner of Phelan and Centola Roads in 2001.

In March 1942, construction started on the Loma Linda Forestry Fire Station. Loma Linda Medical Center leased property on the northeast corner of Barton Road and Anderson Street to the division of forestry for $1 annually. Prior to 1942, the forestry engine and crew were located at the Colton Fire Hall. Assigned to the forestry engine in 1939 were Jack Van Luven and Nick LaPorta. In 1940, a third forestry man, Pat Critchlow, was added to relieve Van Luven and Chris Dunkel. Forestry crew in 1941 included Paul Scott and Howard LaPlante. In January 1935, an agreement was made to keep a state forestry truck in Colton for auxiliary purposes.

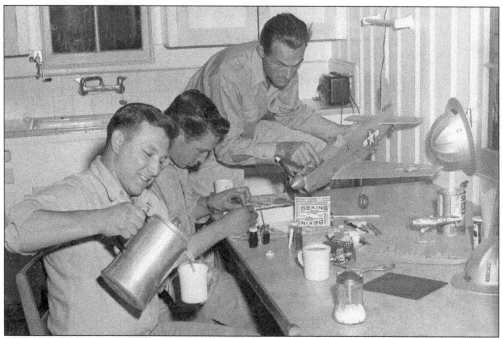

After dinner, the Yucaipa crew enjoys a little hobby activity of building model airplanes. Holding the model is Warren Keehnel. Pouring coffee is Dick Valdez, and the third man is Leo Buckles. In 1957, a majority of forestry stations did not have the luxury of television. Many firefighters filled their free time with hobbies. At the Yucaipa Station, before using the kitchen for hobbies, firefighters cleaned the kitchen after evening meal. If the hired cook was off, firefighters took turns cooking. Some were great cooks, and some were not so great.

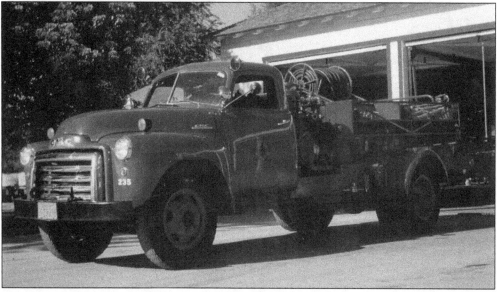

Forestry truck No. 235 is parked in front of San Bernardino Headquarters. This 1948 GMC fire truck carried 400 gallons of water and had a 250-gallons-per-minute Continental auxiliary pump. This style was developed to replace the previous smaller truck that carried 280 gallons of water. Engine No. 235 was stationed at Yucaipa Forestry Fire Station.

1210

examination for

FOREST FIREFIGHTER FOREMAN

(OPEN TO MEN ONLY)

FINAL DATE FOR FILING APPLICATIONS......NOVEMBER 16, 1956
EXAMINATION DATE.........................DECEMBER 8, 1956
SALARY RANGE..............................$325-341-358-376-395 RANGE A
$358-376-395-415-436 RANGE B

RANGE A APPLIES TO EMPLOYEES IN THIS CLASS WHO ARE NOT REQUIRED TO REMAIN "ON CALL" OR ON "STANDBY" DURING THE FIRE SEASON, AND FOR ALL EMPLOYEES DURING OTHER TIMES OF THE YEAR.

RANGE B APPLIES TO EMPLOYEES IN THIS CLASS WHEN REQUIRED DURING THE FIRE SEASON AS DETERMINED BY THE STATE FORESTER, TO REMAIN "ON CALL" OR ON "STANDBY" 24 HOURS A DAY OF THE FIVE REGULAR WORK DAYS.

ENTRANCE REQUIREMENTS

APPLICANTS MUST HAVE BEEN RESIDENTS OF CALIFORNIA FOR A LEAST ONE YEAR IMMEDIATELY PRIOR TO THE DATE OF THE EXAMINATION.

EXPERIENCE: EITHER
1. TWO SEASONS OF EXPERIENCE (TOTALING TEN MONTHS) IN FOREST FIRE SUPPRESSION WORK; OR
2. SIX MONTHS OF EXPERIENCE IN CHARGE OF A CREW OF WORKMEN, INCLUDING OR SUPPLEMENTED BY THREE MONTHS OF FOREST FIRE SUPPRESSION WORK.

FACTS ABOUT THE POSITION

DURING THE FIRE SEASON THE PRIMARY DUTIES OF THE FOREST FIREFIGHTER FOREMAN ARE TRAINING HIS CREW AND FIGHTING FIRES. HE MAY HAVE FULL RESPONSIBILITY FOR THE CONTROL OF SMALL FIRES. DURING THE WINTER SEASON THE EMPHASIS IS ON REPAIR AND MAINTENANCE OF FACILITIES SUCH AS ROADS, TELEPHONE LINES, AND SMALL STRUCTURES. A FOREST FIREFIGHTER FOREMAN MAY ALSO BE ASSIGNED AS ASSISTANT OR RELIEF DISPATCHER ON A YEAR-ROUND BASIS OR DURING THE FIRE SEASON.

FOREST FIREFIGHTER FOREMEN LIVE IN FORESTRY CAMPS OR STATIONS WHICH ARE OFTEN AWAY FROM CENTERS OF POPULATION. DURING THE SUMMER MONTHS WHEN FOREST FIRE CONDITIONS ARE ACUTE THEY ARE ON DUTY OR STANDBY 24 HOURS A DAY, 5 DAYS A WEEK, RESTRICTED TO FIRELINE OR CAMP ASSIGNMENTS. DURING THE REST OF THE YEAR THEY MAY WORK ON PROJECTS REMOTE FROM THEIR HEADQUARTERS AND HOMES.

POSSESSION OF A VALID CALIFORNIA AUTOMOBILE DRIVER'S LICENSE IS REQUIRED.

FACTS ABOUT THE EXAMINATION

PLACE OF EXAMINATION: THE EXAMINATION WILL BE GIVEN IN SUCH PLACES IN CALIFORNIA AS THE NUMBERS OF CANDIDATES WARRANT AND CONDITIONS PERMIT.

PROMOTION: SUBJECT TO CERTAIN CONDITIONS, STATE EMPLOYEES IN THE DIVISION OF FORESTRY, DISTRICTS I, II, III, IV, V, AND VI, WHO HAVE PERMANENT STATUS IN ANY CLASS WITH A SALARY RANGE WHICH DOES NOT EXCEED $376 AT THE MAXIMUM AND WHO MEET THE ENTRANCE REQUIREMENTS MAY PARTICIPATE IN THIS EXAMINATION ON A PROMOTIONAL BASIS. A SEPARATE PROMOTIONAL ELIGIBLE LIST WILL BE ESTABLISHED FOR EACH DISTRICT. FOR PROMOTIONAL CANDIDATES IN THIS EXAMINATION, THE MINIMUM REQUIRED OVER-ALL RATING IS 74%. FINAL RATING WILL BE COMPUTED ACCORDING TO THE RELATIVE WEIGHTS ANNOUNCED.

ELIGIBLE LIST: A SEPARATE ELIGIBLE LIST WILL BE ESTABLISHED FOR EACH DISTRICT.

SCOPE OF THE EXAMINATION

A MINIMUM RATING OF 70% MUST BE ATTAINED IN EACH PART OF THE EXAMINATION.

WRITTEN TEST: WEIGHTED 6

1. KNOWLEDGE OF THE STATE FOREST AND FIRE LAWS.
2. KNOWLEDGE OF THE CHARACTERISTICS OF FOREST FIRES AND OF FIRE SUPPRESSION METHODS, EQUIPMENT, AND TERMINOLOGY.
3. KNOWLEDGE OF THE METHODS USED IN THE REPAIR AND MAINTENANCE OF FORESTRY EQUIPMENT, AND ABILITY TO OPERATE SUCH EQUIPMENT SAFELY.
4. KNOWLEDGE OF THE ELEMENTS OF FORESTRY TELEPHONE LINE INSTALLATION, FIRE ROAD CONSTRUCTION, AND OF ELECTRICITY, PAINTING, PLUMBING, AND CARPENTRY.
5. ABILITY TO READ AND USE MAPS AND CHARTS.
6. FAMILIARITY WITH THE PRINCIPLES OF EFFECTIVE SUPERVISION.

FOREST FIREFIGHTER FOREMAN
(OPEN TO MEN ONLY)
9/28/56

(OVER) SALARY RANGE: SEE ABOVE

Here is a 1956 California Division of Forestry job announcement for forestry fire foreman, today's fire captain. Starting pay in 1956 was $325 a month, and the foreman worked a five-day week. In 1959, alternatives were being considered, like a four-day workweek or hiring more relief firefighters; however, it was questionable as to whether the state budget would allow the increased costs. A 1942 announcement for assistant state forest ranger reported an entry-level salary of $130 a month. In 1956, a state forestry firefighter was paid $281 a month and worked 24 hours a day, five days a week at their station. A 1970 independent survey showed state forestry firefighters 25 percent behind other fire departments in compensation. Today, the entry-level firefighter is paid minimum wage. The average workweek in 1970 was a continuous 120-hour week. Currently, CAL FIRE firefighters work a continuous 72-hour workweek.

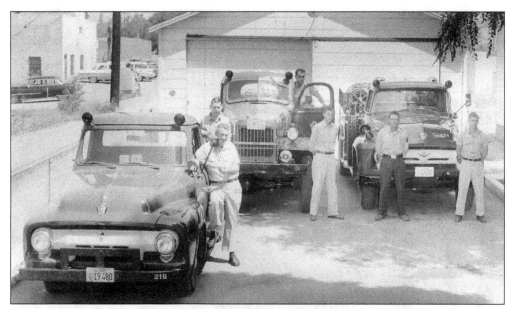

A new pumper truck for Yucaipa is pictured at center in 1957. Standing beside his pickup in the left foreground is Art Balsom, assistant ranger for Yucaipa; behind him is John Jory. Standing in the cab of the new pumper is driver Bob Clanton. The others are, from left to right, firefighter Gerold Golden, foreman Chuck Meidell, and Bill Havins. Meidell, prior to serving in the Korean War, was the Morongo Valley patrolman. After returning from Korea, he was assigned to Yucaipa and retired from the Pilot Rock Conservation Camp.

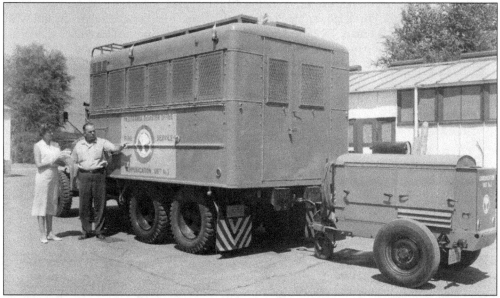

Established in 1956, the California Disaster Office provided military-surplus civil defense equipment to counties and cities within California. Pictured is an example of the communications unit stored at the San Bernardino Headquarters of the California Department of Forestry. In May 1965, in conjunction with the California Disaster Office, California Division of Forestry, and the San Bernardino National Forest, Chief F.D. Newcomb conducted a one-day exercise in Waterman Canyon simulating a brushfire threat to mountain communities.

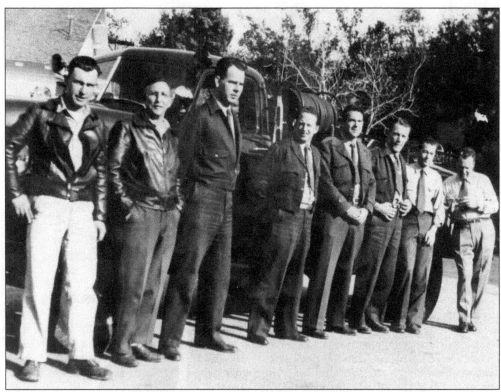

San Bernardino State Forestry executive staff of 1958 included, from left to right, Larry Shay, Harvey Gillett, Chuck Ulrey, Howard LaPlante, Art Balsom, Tom Bryan, Paul Scott, and W.W. "Butch" Skinner. On February 15, 1962, Ulrey attended a meeting of the Governor's California Disaster Office as an employee. By November of that year, Paul Scott also went to work for the California Disaster Office and attended the meeting in Sacramento.

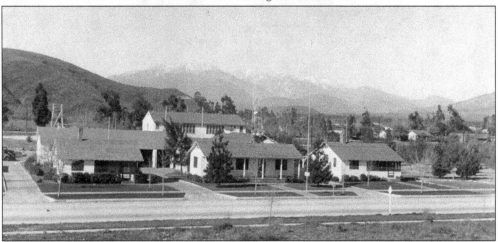

This view is looking west toward the San Bernardino Headquarters of California Division of Forestry. In 1958, the residences to the left and right of the headquarters office building were occupied by the county ranger and his assistant. Paul Scott, the assistant, occupied the building on the left, and Butch Skinner was in the building to the right. Crews worked 120 hours per week and often longer during fire season.

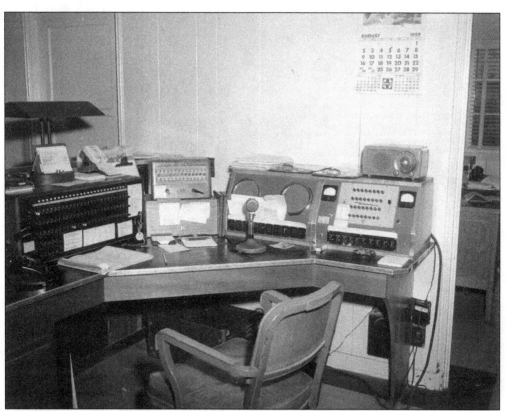

This is a 1959 view of the radio room at the San Bernardino Headquarters. At that time, a dispatcher typically worked a four-day 24-hour shift. At night, the on-duty dispatcher was able to take advantage of a bed in an adjoining room, only to be awakened by a ringing emergency phone call. At the time, emergency calls went directly to the local fire station. The station personnel received the emergency information and relayed it to the dispatcher for dispatching of appropriate emergency equipment.

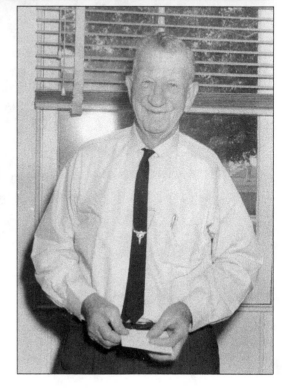

State forestry cook Herbert Smith was assigned to Etiwanda Forestry Station. Smith worked as a cook from 1957 to 1965. The 1955 pay for forestry cook was $100 a month, and the cook was expected to provide three meals a day, five days a week. During major brushfires, forestry cooks were brought to the fires to prepare meals for up to 650 firefighters.

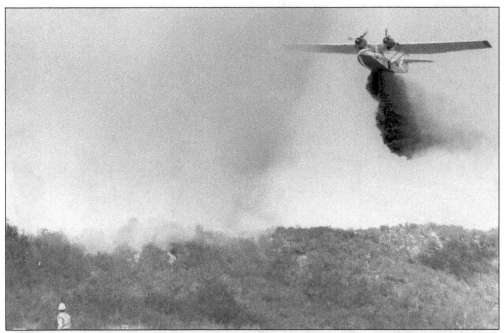

A Consolidated PBY Catalina air tanker makes a drop on a fire in the Yucaipa area. In the early 1970s, the California Division of Forestry had one PBY aircraft under contract. Use of the aircraft started in the late 1950s. The aircraft's slow speed, when compared to others, and its 1,500-gallon tank provided accuracy and good coverage on drops.

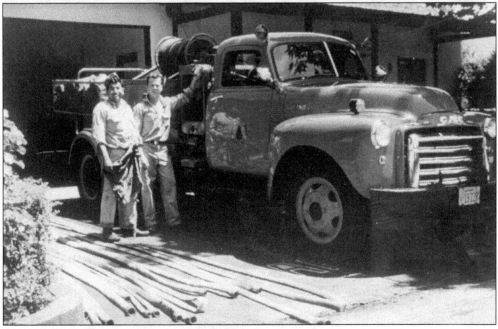

Forestry fire foreman Louie Sanchez (left) and 19-year-old firefighter Jerry Newton are seen at Loma Linda Station in 1959. The 1948 GMC fire truck had room for two firefighters in the cab, and three firefighters standing on the tailboard. On August 5, 1959, the Loma Linda forestry engine was assigned to the 11,200-acre Lake Gregory fire.

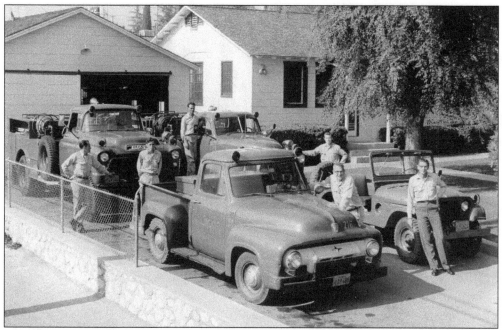

Representing the 1959 Yucaipa Forestry Fire Station crew are, from left to right, driver Jack Tilley, unidentified, firefighter Warren Keehnel, forest firefighter foreman John Pogue, assistant state forest ranger Charles "Art" Balsom, and forest firefighter foreman Bob Dalgity. Pogue, in the early 1960s, left forestry to work for the San Bernardino City Police Department, retiring as a detective.

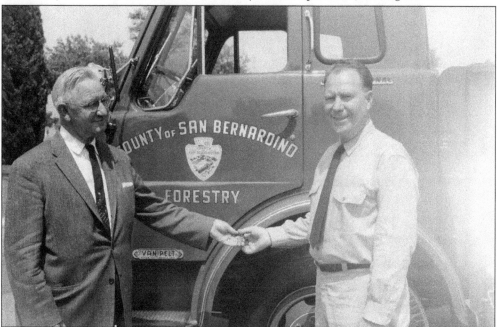

In June 1960, a new fire engine was purchased for the fire warden of California Division of Forestry, San Bernardino County. The 1960 257-horsepower 750-gallons-per-minute Van Pelt replaced aged government-surplus equipment. Prior to this, the division of forestry built all its fire engines from military surplus. Here, board chairman S. Wesley Break presents the keys to Chief W.W. Skinner.

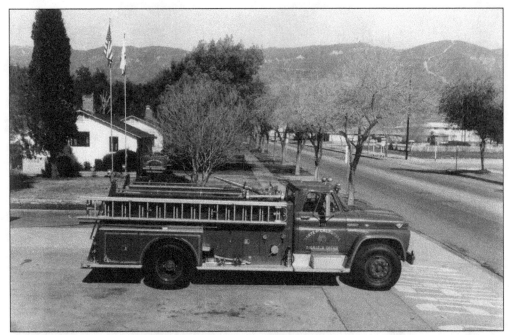

This State of California Disaster Office fire engine was assigned to San Bernardino Forestry Headquarters. Originally named the Office of Civil Defense from 1945 to 1950, authority created by the California Disaster Act was enacted by the California state legislature in 1945. The first 43 of 58 engines were ordered at a cost of $12,950 each, which included equipment.

Wilfred "Butch" Skinner retired from his position of ranger in charge of the San Bernardino Ranger Unit on July 31, 1967. Skinner started his forestry career with the California Division of Forestry in 1933 and became chief ranger in the spring of 1942. It was only months before that he entered the Army Air Corps. Skinner returned from his tour of duty in 1946 and was reinstated to the position of state ranger in charge of San Bernardino.

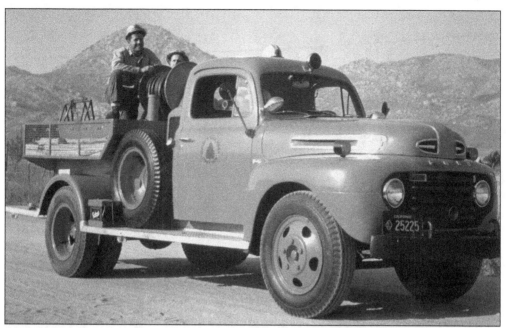

These forestry crew members are on patrol of a 1,400-acre Box Springs brushfire. Pictured are firefighter Bob McConnell, driver Ray Russell, and forestry fire foreman Lou Brundige. The fire ultimately burned 1,440 acres, having started behind the University of California at Riverside Campus on August 19, 1963. The fire burned through a radio transmission site at the top of the mountain that was used by the Riverside Sheriff's Office and state forestry.

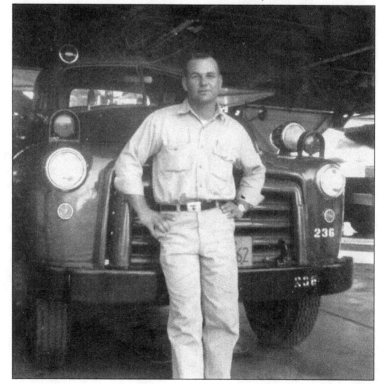

Duane Kelly is pictured in front of CDF San Bernardino Headquarters. Kelly, a resident of Highland, started as a volunteer with the Highland volunteer firefighters and began his career with the division of forestry in 1943 at San Bernardino Headquarters. During his forestry career, Kelly worked in various positions in San Bernardino and Santa Cruz Counties.

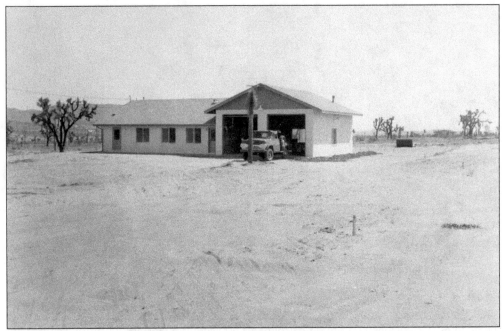

Yucca Valley Forestry Fire Station, located at 7105 Airway Drive south of Highway 62, is shown shortly after construction in 1964. From 1946 to 1960, the forestry crew was assigned to Twentynine Palms. In 1960, the crew was located with the Yucca Valley Fire Protection District until completion of the Yucca Valley Forestry Station.

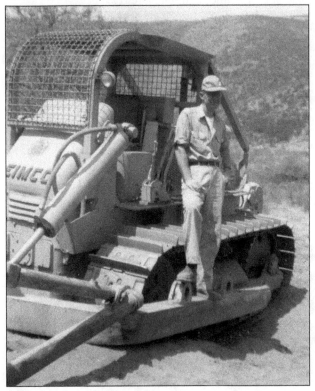

Warden Matt Muellier, division of forestry's heavy fire equipment operator, is standing with the EIMCO dozer. The operator sat between the engine and the blade. The dozer was all hydraulics, and if the engine quit, the operator lost control and brakes. Due to the issues of heat from the engine and being so close to the blade and fire, along with the issue of loss of braking and engine failure, it was traded with the California Division of Highways for a D6 Caterpillar dozer. Only one EIMCO was purchased.

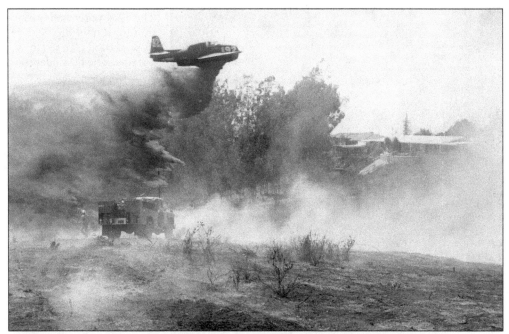

An air tanker is dropping on the Overcrest fire in September 1964, between Redlands and Yucaipa. The aircraft used to fight this fire was a converted World War II Navy TBM Avenger torpedo bomber. On July 5, 1959, a TBM air tanker crashed while flying over a fire in the Crafton Hills of the community of Yucaipa.

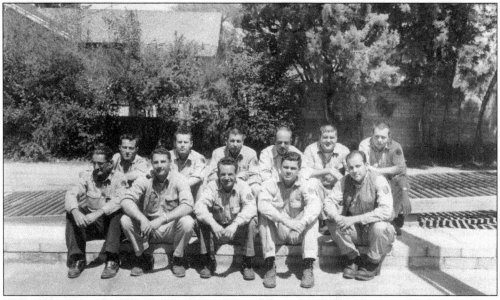

These California Division of Forestry, San Bernardino, personnel are, from left to right, (first row) Bill Duncan, Lou Brundige, Paul Alaniz, Dick Hannum, and Bill Wirth; (second row) Tom Fennel, Dave Westover, unidentified, Ernie Wasley, Frank Lemelin, and Ron Bywater. Brundige, after serving with the California Department of Forestry for 38 years, retired on June 26, 1990. At 17, he quit school to be a firefighter. He had picked up a taste for the work while hanging around fire stations when he was 14 years old.

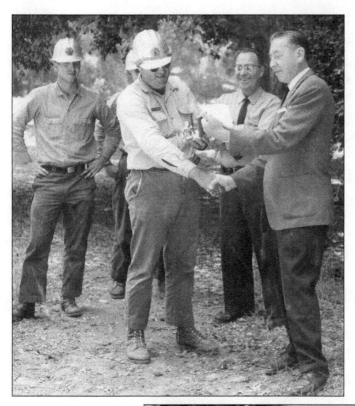

The 1964 watershed fire training school was held in Wildwood Canyon in Yucaipa. The 80 students, some from the Oak Glen Youth Center, slept in sleeping bags and ate food from a forestry field kitchen. Dewitt "Swede" Nelson, state director of natural resources, presented the trophy to the best team. Frank Lemelin and his crew received the trophy.

Pictured in 1964 are San Antonio Heights Forestry Fire Station crew members, from left to right, firefighters Ray Regis and George O. McGuire, driver David Brown, and forestry fire foreman Tom Andreas, recently promoted from Sanger, Fresno County CDF. In March 1971, McGuire received the California State Medal of Valor for rescue efforts taken on March 18, 1968, while assigned to California Division of Forestry, Riverside County, in the Sunnymead District.

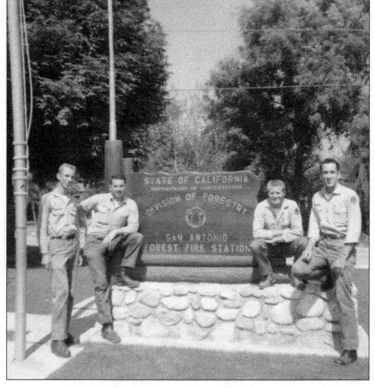

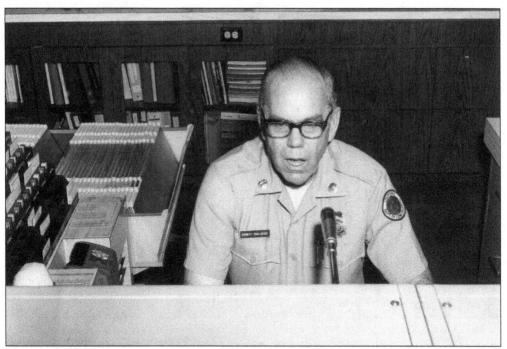

Everett Smallwood dispatched for California Division of Forestry, San Bernardino, from 1956 until his retirement in 1975. Smallwood started his career with the division of forestry in 1940, when he was assigned to the forestry crew located at the Colton Fire Hall. He was promoted to foreman (captain) in 1948 and was reassigned to the dispatch center in 1956.

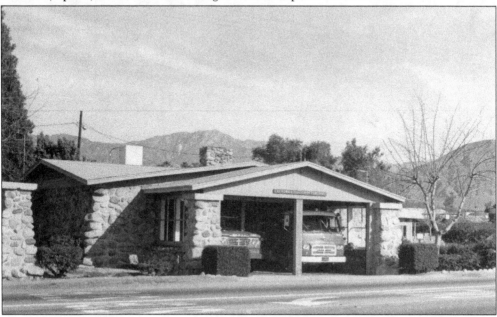

This c. February 1970 photograph shows Mentone Forestry Station. The building had been vacant since the death of Gabriel Basor in July 1942. On taking possession of the building, George Meers took a fire hose from his engine and washed the building out. A large fire was built in the fire place to help dry the building.

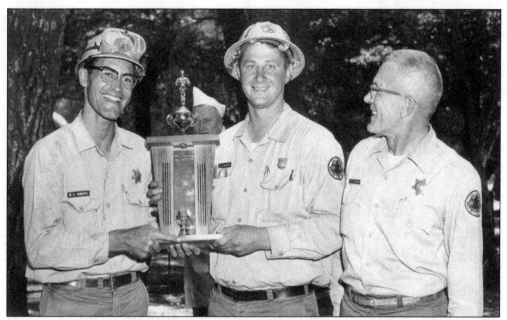

From left to right are state forest ranger Bill Sanders, forestry foreman Lou Brundige, and deputy ranger Tom Bryan. Sanders and Brundige are receiving a trophy for winning the 1965 fire school. Judging was based on speed, accuracy, safety, leadership, and the group's initiative in facing unexpected situations. Approximately 30 firefighters from the division of forestry attended the training near the Hunts Boy Scout Camp in Wildwood Canyon east of Yucaipa.

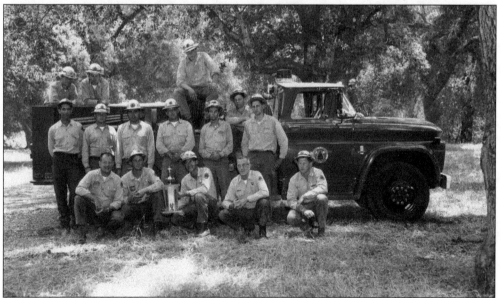

Among the winners of the 1965 fire school were, from left to right in the first row, Bill Downing, Lou Brundige, Bill Sanders, Tom Bryan, and Duane DeClerck. Identified in the second row are Bill Laster; John Ingram, fifth from left; and Dean Farmer, sixth from left. The engine was No. 573 from Hesperia. Sanders, who started his career in the division of forestry in 1949, was promoted in February 1965 to assistant state forester for the Hesperia District. He replaced Robert Lix, who went to Oak Glen Youth Camp as an associate ranger.

Shown in 1965 are some of the Yucaipa forestry firefighters. From left to right are Bob Martines, Mike Hannifan, and Warren Keehnel. Martines, after serving more than 36 years, retired on July 31, 2001. He started his career with the California Division of Forestry in 1964 at the Yucaipa Forestry Station in San Bernardino. After serving with the US Marines, he was appointed to engineer in Riverside County in 1966. Martines held the position of the south area chief in Riverside County on retirement.

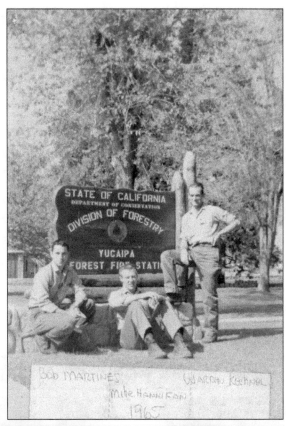

San Bernardino County received four 1954 International military six-by-six chassis with Van Pelt bodies in 1966. They had a 450-gallons-per-minute pump and a 1,000-gallon tank. Over the years, they were placed at different stations. The six-wheel-drive chassis were a great benefit in off-road firefighting.

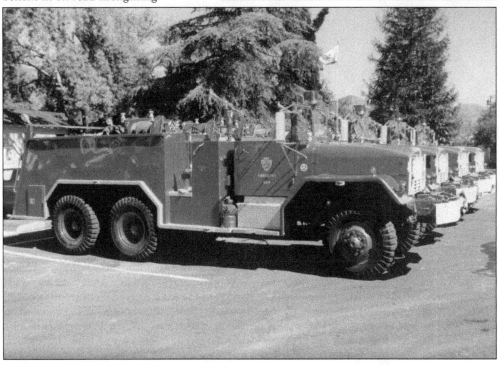

Jack Burke graduated from San Bernardino High School in 1937 and attended two years of college. On November 7, 1943, he entered the Marines as a private and was stationed at Camp Pendelton, where he studied Japanese language. At the time of his enlistment, he held the position of assistant ranger for the California Division of Forestry. On May 22, 1967, Burke was introduced to the San Bernardino County Board of Supervisors as the new county fire warden.

In July 1962, state forester and county fire warden W.W. Skinner reported that a forestry crew would be housed at a leased residence near Highway 18 west of the Old Woman Springs intersection "the Y." Bids were called for a station to be constructed on the northeast corner of Pioneer Park in Lucerne Valley. Two efforts to form a local fire district had failed a year earlier, and the community had reportedly been without fire protection. California Division of Forestry built the Lucerne Valley Forestry Fire Station for a cost of $26,741 in 1965.

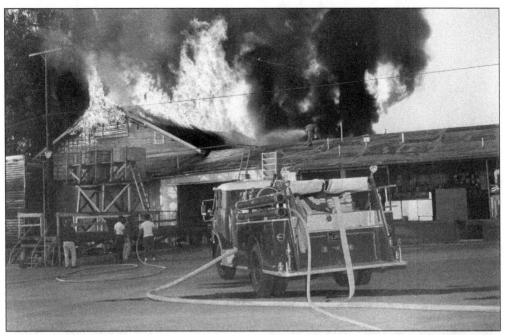

On January 24, 1968, the Yucaipa Farmer's Cooperative, located at 34945 Yucaipa Boulevard, caught fire. Fire captain Lou Brundige is pictured on the roof. Firefighters were hampered by walls filled with sawdust used for insulation and by low water pressure. Fire trucks had to lay supply hose from several blocks away to provide adequate water to control the fire.

A forestry cook is serving dinner to Yucaipa Forestry Station crew members. From left to right are Mark Hirons, Mike Fink, Warren Keehnel, cook Louise Clanton, state forest ranger Larry Young, and Lou Brundige. In 1974, Louise Clanton began her third year as a cook for the California Division of Forestry Yucaipa Station. Prior to Yucaipa, Clanton worked two seasons in Oroville, California.

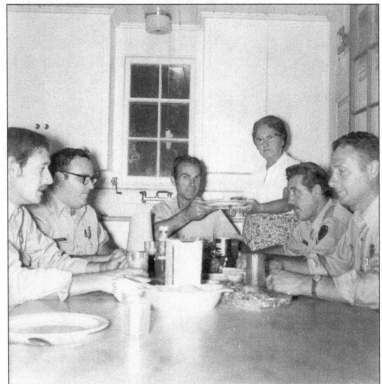

Frank Quadro was appointed state ranger in charge and San Bernardino County fire warden on August 22, 1972. After graduating from the University of California at Berkeley forestry program in 1951, Quadro started his forestry career in Redding as a forestry assistant in 1963 and also served in Napa, Lake, and Humboldt Counties. A World War II Navy veteran, he served in the Pacific from 1943 to 1946. In July 1975, Quadro was promoted to assistant deputy state forester at the California Department of Forestry Region Office in Riverside.

Rex Griggs was appointed San Bernardino County fire warden and state forest ranger in charge in July 1975. Prior to San Bernardino, Griggs was fire control officer for California's North Coastal Region and was in charge of fire control from San Francisco to Oregon. Early in Griggs's career, in 1953, he was assigned to the Fresno Kings Ranger Unit at Chowchilla.

Duane Kelley is learning to operate a D-7 Caterpillar bulldozer. Currently, CAL-FIRE heavy equipment operators have a prerequisite requirement of one year's experience operating class 8 transport vehicles and one year operating D6 or D7 bulldozers. After completing a five-week CAL FIRE dozer operator academy, operators must also complete Basic Fire Control firefighter academy and Company Office Academy within one year of employment.

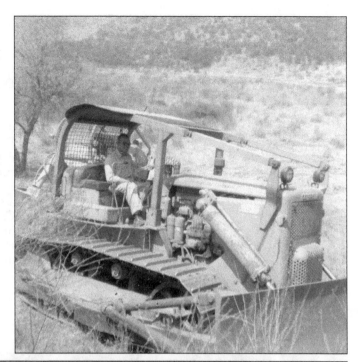

The California Division of Forestry emergency command center dispatchers of San Bernardino County are, from left to right, (standing) Doug James, Don Ashley, Jim Hunter, Jim Reeder, and Darrel Alexander. Kneeling at center is assistant ranger Howard Wright. According to the 1976 San Bernardino Department of Forestry annual report, the San Bernardino Forestry Emergency Command Center processed 3,448 emergency calls and an additional 1,040 calls for Crest Forest Fire Protection District.

In April 1974, Don C. Banghart was promoted to chief of San Bernardino County, California Department of Forestry, and county fire warden, having previously held the position of deputy chief of the California Department of Forestry, Riverside County, for the past two years. Banghart first came to San Bernardino in 1973 as assistant chief from Northern California. He received his bachelor's degree from Humboldt State University in forestry management.

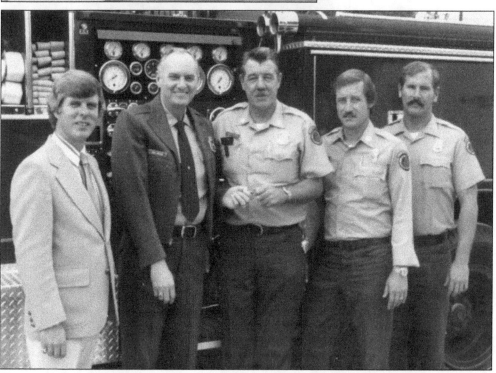

Here, a newly acquired fire engine is presented to the Yucaipa Station. From left to right are San Bernardino County Third District supervisor Dennis Hansberger, California Department of Forestry ranger and San Bernardino County fire warden Rex Griggs, state forest ranger Larry Young, Mark Hirons, and Jack Story. Shortly after the December 10, 1977, Yucaipa dedication, a similar engine was dedicated at the Mentone Station.

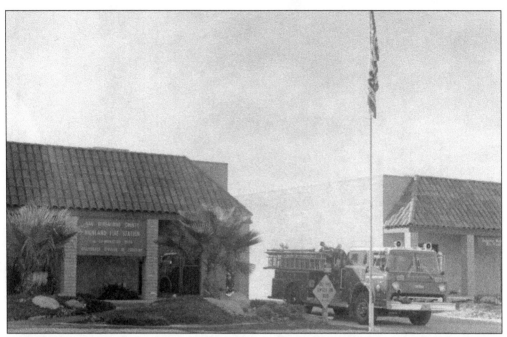

In September 1977, Highland Fire Station No. 6 was relocated to 27213 East Fifth Street in Highland. Earlier in July, the San Bernardino County supervisors approved a land purchase at Victoria and Pacific Avenues. However, this site was not used. In August 1981, the station was moved to 26974 Baseline Street.

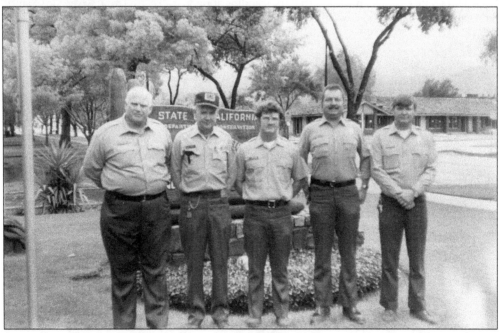

Pictured are dozer operators, also known as heavy fire equipment operators, and a mechanic. From left to right are Henry Koelh, Virgil Andrea, mechanic Amos Stedham, Conrad Damien, and Don Williams. In January 1949, California Division of Forestry equipment operators earned $243 a month. Virgil Andrea retired in October 1979.

Chris Wurzell, kneeling at left, and Stephen Bangle, kneeling at right, became CAL FIRE's first paramedics in San Bernardino County; on their own time, they completed the nine-month paramedic training at Crafton Hills College. In March 1979, Mike Marlow, standing at left, transferred from Crest Forest Fire District, and Kenneth Pitts, standing at right, transferred from Riverside County. The extra staffing provided seven-day-a-week coverage for the paramedic program.

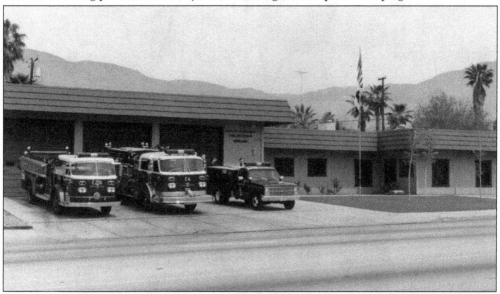

In November 1980, land was purchased at 26974 Baseline Street, and a new Highland Fire Station was built to replace the Fifth Street location. In 1981, the station at Fifth Street was relocated to the Baseline Street location. The City of Highland's separation from County Service Area No. 38 (CSA-38) caused the renumbering of all Highland fire stations. Station No. 6 was renumbered to No. 541.

Battalion chief Ray Snodgrass of the East Valley Battalion is seen at a structure fire in the city of Yucaipa. Snodgrass started in San Bernardino in 1979 as the new battalion chief for the Needles Battalion, coming from Riverside County. In 1980, he transferred to the Emergency Command Center and, in 1985, to the Yucaipa Battalion. Snodgrass was eventually promoted to chief deputy director of the California Department of Forestry in Sacramento.

From the original support staff of three secretaries in 1938 to over 20 dedicated office staff and secretaries in 1987, as the department grew, so did the need to support the mission. From left to right are (first row) John Charlier, unidentified, Miriam Delgado, Kathy Downing, Cathy Reiboldt, Ruth Torres, unidentified, Nancy Weatherbie, and Brenda Seltenrich; (second row) Brenda Donalson, Lovae Pray Martines, Randy Booker, Dianne Brossard, Dee Dee Ruiz, Mary Livermore, Shirley Nettleton, Donna Snodgrass, Maureen Shouse, Joani Koontz, and Mary Grisamore.

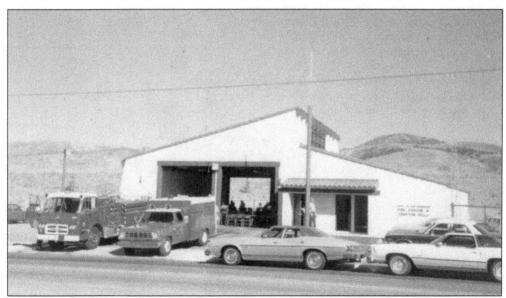

Dedication of the Crafton Hills Fire Station No. 18 took place on October 14, 1978. The dedication, coinciding with National Fire Prevention Week, was a daylong open house with San Bernardino County Third District supervisor Dennis Hansberger as the guest speaker. Construction began earlier in the year with a cost of $235,000.

On July 1, 1986, California Department of Forestry ranger in charge and San Bernardino County fire warden Glen Newman, left, and San Bernardino County Third District supervisor Barbara Riordan place a paramedic placard on medic squad van No. 6 in the city of Highland. In November 1985, the voters had approved a paramedic tax assessment to fund the city's paramedic program.

Pictured in 1987 are the San Bernardino County chief officers of the California Department of Forestry. They are, from left to right, (first row) Jack Consol, Tom Greenwood, George Pond, Dave Golder, Bob Green, Candice Gregory, and unidentified; (second row) John Clark, Kevin Eggleston, Howard Wright, Paul Benson, Mark Brodowski, Dwayne Martin, and George Fronek.

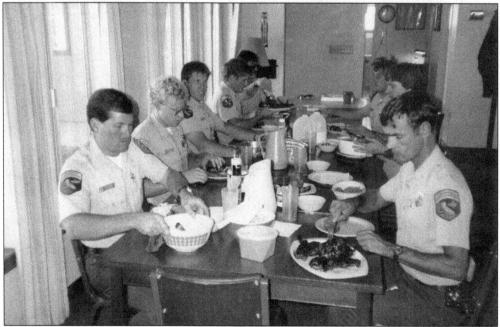

Here, the Yucaipa Fire Station crew might be lucky to finish their dinner before a call. On the left are, from front to back, seasonal firefighter John Schnell, engineer Robert Cone, firefighter Danny Ulvevadet, seasonal firefighter Scott Souter, and firefighter Randy Borges. On the right are, from front to back, paramedic engineer Tom Clark, paramedic engineer Neil Williams, and engineer Kevin Miller. In 1987, seasonal firefighters worked a continuous 96-hour four-day week.

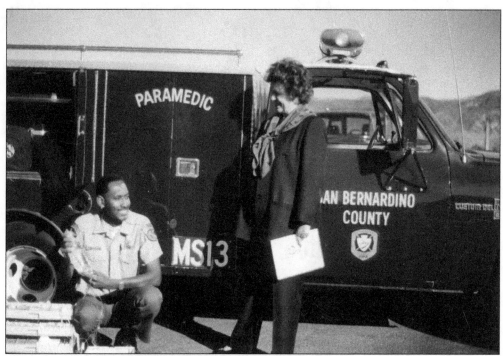

San Bernardino County Third District supervisor Barbara Riordan is observing fire apparatus engineer paramedic Al Adams explain the use of intravenous solutions at California Department of Forestry Yucaipa Station 13. In June 1987, property owners in the Yucaipa and Oak Glen communities approved a property tax assessment to fund paramedic services.

Glen J. Newman was the California Department of Forestry unit chief and San Bernardino County fire warden from January 31, 1986, to November 30, 1988. Newman started his 40-year career at the Elsinore Forestry Fire Station in Riverside County in 1961 and served two years in the US Army in Germany, from 1965 to 1967. After serving, he returned to Riverside County. In January 1974, Newman was promoted to fire captain specialist in San Bernardino. He retired in December 2001 as the deputy director of fire protection for the California Department of Forestry.

San Bernardino Forestry chiefs for 1988 are, from left to right, Frank Villalovos, state ranger II; Tim Shay, state forest ranger III; John Timmer, state forest ranger I; Ralph Allworth, state forest ranger II; Bob Balistreri, state forest ranger II; and Dave Driscoll, state forest ranger IV. Later on, the civil service titles of state forest ranger changed to battalion chief, division chief, deputy chief, and unit chief.

In August 1971, Dave Driscoll started his career as a firefighter with the California Department of Forestry at the Orange County Airport. Following various moves and titles, he was promoted to Southern California Region Office in 1980. In December 1988, Driscoll was promoted to unit chief in San Bernardino Ranger Unit. During this time, the California Department of Forestry, San Bernardino County, fire warden administered a fire department of 1,000 paid and volunteer firefighters, operating out of 49 fire stations. In April 1996, Driscoll was promoted to Assistant region chief of CDF Northern Region and retired in August 2004.

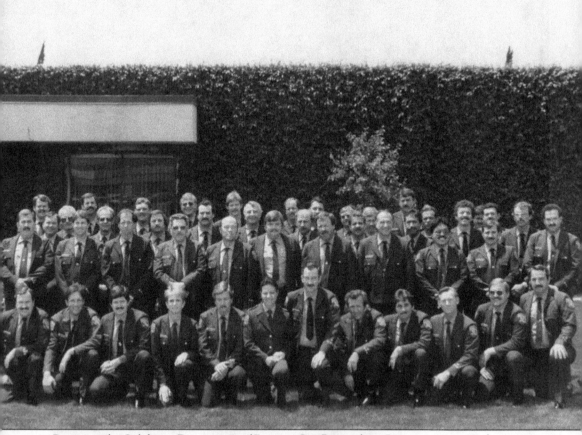

Present at the California Department of Forestry, San Bernardino County, ranger unit fire captains meeting at the Norton Air Force Base's Noncommissioned Officers' Club on May 11, 1988, were, from left to right: (first row) Glen Newman, William Shultz, Ralph Allworth, Ernylee O'Keefe, Steve Dale, Evelyn Armenta, Tim Shay, John Cowan, Marvin Eaves Jr., Jim Smith, Bob Green, and Bob Martines; (second row) Bruce Brown, Steve Ruddell, Steve Hansler, Carl Bethrum, Bob Oechener, Don Williams, Jerry Taylor, Jim McClellan, Frank Kawasaki, Jerry Hendershot, and Kevin Eggleston; (third row) Bob Burhle, Jerry Alexander, Derek Smethurst, Jack Consol Jr., John Livermore, Lou Brundige, Tim Ricker, Tim Maloney, Dan Fries, Dan Wurl, Jim Rankin, and Darrel Strong; (fourth row) Doug Lannon, Henry Brachais, Roger Henry, Mark Brodowski, Phil DeClerck, Lyle Drenth, Tom Andreas, Bob Taylor, Scott Kuhn, John Timmer, Mike Fernandez, and Rod O'Connor. The meeting was the result of unit chief Glen Newman presenting department goals, objectives, and safety guidelines for the approaching fire season.

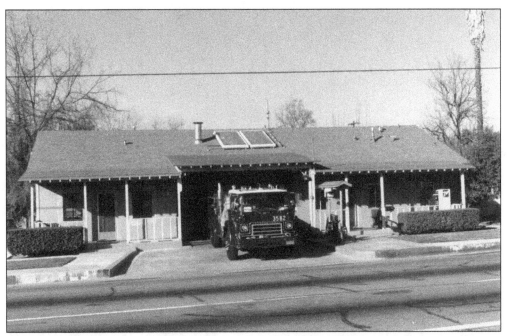

Loma Linda Forestry Fire Station is seen as it looked in 1989 on the northeast corner of Barton Road and Anderson Avenue in Loma Linda. In 1992, the Loma Linda Forestry Station was closed, and equipment and personnel were reassigned to other stations in the county. The engine was relocated to the High Desert Battalion.

Capt. Frank Kawasaki, assistant fire protection planning officer, conducts a fire flow test at the Calnev pipeline. In 1985, the fire protection planning staff conducted over 1,300 building and safety projects. The planning officers served on several committees such as development review, highway planning, and Geographic Information Mapping System (GIMS). The planning officers also coordinated production of the GIMS emergency response map books.

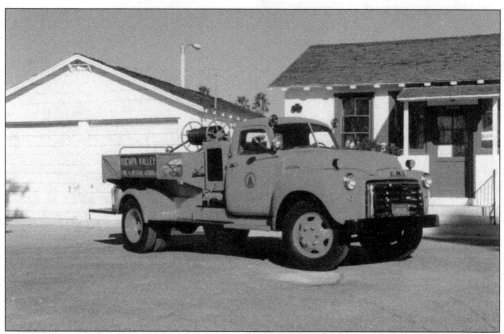

A fully restored 1948 GMC fire engine is parked at the historic Yucaipa Forestry Fire Station. Complete restoration took place at the Prado Conservation Camp. The project was started by retired fire captain Lou Brundige. Through his efforts, Brundige found this engine, which had been assigned to Yucaipa Station. It is now the property of the Yucaipa Fire and Rescue Association.

Chino Hills Station was built in 1986 at the entrance to Prado Conservation Camp. In 2001, the mobile home was removed, and a new station was constructed on site. The mobile home that was used temporarily to house the Chino Hills Fire Station was originally used after the Sylmar earthquake damage at the San Fernando Veterans Hospital.

Paul Benson joined San Bernardino Ranger Unit in 1985 when he was promoted from captain in the Lassen-Modoc Ranger Unit to battalion chief for the San Bernardino Central Desert Battalion. In 1993, Benson was promoted to deputy chief, and in 1995, he was promoted to unit chief for the San Bernardino Ranger Unit. Chief Benson served as unit chief until 1999, when he left CDF to serve as a municipal fire chief. Chief Benson cites his most difficult time during his career as the loss of the county fire warden contract and the impacts of that on more than 80 personnel. This difficult transition spanned nearly three years, and Chief Benson says his two most rewarding career accomplishments were the successful placement of every affected employee and laying the groundwork for contracts with the cities of Highland and Yucaipa.

Phelan Forestry Fire Station in 2002 was relocated to 9600 Centola Road, south of Phelan Road. After completion of the new station, crews from the old Phelan station and from Hesperia Forestry Station were relocated to the new facility. For a brief period, three forestry engine crews were housed in a building designed for two engines.

Construction of the new Phelan Forestry Station took two years longer than expected. Unfortunately, problems arose, and the original contractor left the building uncompleted and vacant for over a year. Eventually, after removing pigeons and contamination from the facility, the station was finally opened. Even years after construction, problems with defective materials have been found.

Robert Green Jr. transferred to the San Bernardino Ranger Unit to become battalion chief from Monterey in 1987. Green was promoted to division chief in San Bernardino and Riverside Counties prior to being promoted to deputy chief at the Southern Area Operations Center in Riverside. In 2003, Green returned to San Bernardino as CAL FIRE unit chief and held the position for three years prior to accepting a position again at the Southern Area Operations Center.

Construction of the new Chino Hills Forestry Fire Station was completed in 2002. On April 17, 2013, a firefighter assigned to the Chino Hills Forestry Fire Station was awarded the Governor's Medal of Valor for action taken in August 2012 while returning from a fire assignment in San Diego. Brian Cali is among 111 CAL FIRE employees who have been given the award.

In 2006, CAL FIRE signed a "call when needed" contract with 10 Tanker and established a Very Large Air Tanker base at the Victorville airport. Tanker 910's first use was on the Sawtooth fire in the Yucca Valley community of San Bernardino County. The agreement was terminated in 2012.

Tom O'Keefe served CAL Fire from 1974 to 2009. Prior to becoming the San Bernardino Inyo-Mono unit chief, he was assigned to the Orange and Riverside Ranger Units. In response to the bark beetle infestation, Chief O'Keefe worked with public agencies and private corporations to form the Mountain Area Safety Task Force (MAST). The MAST agencies removed dead and dying trees from the San Bernardino Mountains (Crestline, Lake Arrowhead, Running Springs, and Big Bear), resulting in the safe evacuation of residents during the 2003 Old/Grand Prix fire.

Chief Doug McKain came to San Bernardino Unit in 1989 as a fire crew supervisor assigned to the Fenner Conservation Camp until 1998, when he was promoted to CAL FIRE Riverside as battalion chief. In 2000, McKain returned to San Bernardino as administrative chief and, in 2009, was promoted to unit chief, retiring in 2011.

Chief Tim McClelland started his fire service career in 1981 as a volunteer firefighter in Riverside County at the Sun City Fire Station. In 1985, McClelland was hired as a seasonal firefighter with California Department of Forestry in Riverside County and was promoted through the ranks to battalion chief in 2001. After being promoted to assistant chief in 2003 at the CAL FIRE South Region Operations Center, McClelland transferred to San Bernardino Unit in 2005, serving as the assistant chief of Pilot Rock Conservation Camp. In 2009, McClelland was named to deputy chief and, in 2011, was promoted to unit chief of San Bernardino.

In April 2013, a cooperative agreement was signed between CAL FIRE and the Baldwin Lake Volunteer Fire department in the community of Baldwin Lake, which is located north of Big Bear Lake. The agreement was necessary as the result of realignment of State Responsibility Area fire protection formerly provided by the US Forest Service. Stations at Crestline and Running Springs in the San Bernardino Mountains also resulted from the realignment.

San Bernardino unit chief Rod Bywater began his CAL FIRE career in 1986 as a seasonal firefighter in Riverside County and became an engineer in 1989. Bywater's promotion to captain in 1994 brought him to the Prado Conservation Camp. Bywater eventually returned to Riverside County, working as a truck company captain. Bywater was promoted to battalion chief in 2001 and, in 2011, placed in the position of deputy chief in San Bernardino. In January 2012, Bywater was appointed San Bernardino unit chief and retired in December 2014.

Darren Feldman was appointed unit chief for San Bernardino CAL FIRE effective December 29, 2014. Feldman began his fire service career in 1984 as a paid-on-call firefighter in the city of Highland. In 1985, he was hired as a seasonal firefighter at the Loma Linda Forestry Fire Station. He was promoted to captain at the Fenner Canyon Conservation Camp in 1995.

Three

COUNTY SERVICE
AREA NO. 38

In October 1969, a proposal was drafted that called for the annexation of San Bernardino County, which had little to no fire protection, into what would be County Service Area No. 38 (CSA-38). This proposal, fostered by the San Bernardino County Board of Supervisors, was to eliminate double taxation (by city and county) in places that already had their own established fire protection.

County Service Area No. 38 was eventually formed in 1970–1971. It covered all areas outside of the US Forest Service boundaries and private lands within forest boundaries, which have been protected through the cooperative agreement with the California Department of Forestry, now CAL FIRE, since August 1930.

The first improvement zone was designed to provide extra financing for fire protection within CSA-38 and was established in the Angeles Oaks community east of Redlands in sections Nos. 21, 22, 27, and 28 in the San Bernardino Mountains. Other improvement zones were later established. Nearly 53 paid and volunteer fire stations were administered and staffed through the cooperative agreement with the California Department of Forestry.

In 1993, efforts at further consolidation of the San Bernardino County fire services were initiated by the San Bernardino County Board of Supervisors. Eventually, on June 30, 1999, the board cancelled the cooperative agreement with the California Department of Forestry and consolidated CSA-38 county fire protection under the San Bernardino County Consolidated Fire Agencies. The cities of Yucaipa and Highland are detached from CSA-38 and contract directly to CAL FIRE.

Currently, CAL FIRE in San Bernardino County has state funded fire engines at Chino Hills, Devore, Yucaipa, Crestline, Phelan, Apple Valley, Running Springs, Baldwin Lake, Sky Forest, Lucerne Valley, and Yucca Valley. CAL FIRE continues to provide a cooperative fire protection agreement to the cities of Yucaipa and Highland. San Bernardino CAL FIRE also provides wildland fire protection contracts to the cities of Redlands, Loma Linda, Colton, and Chine as well as Chino Valley Fire District and Rancho Cucamonga Fire Protection District. Dispatch services are also provided through contract to the communities of Arrowbear Lake, Daggett, Morongo Valley, Newberry Springs, and Yermo.

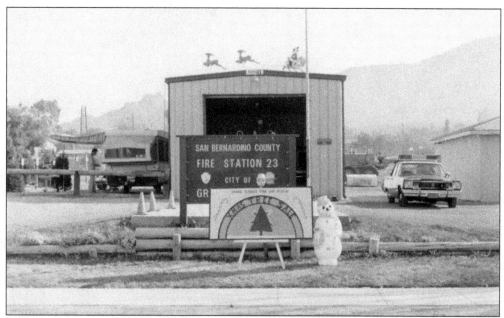

The first fire station for the community of Grand Terrace was authorized by the San Bernardino County supervisors in March 1978. The site chosen was south of Barton Road. An unoccupied residence was used for living quarters, and another structure was built to house the fire equipment. A fire engine and crew were transferred from the Loma Linda Forestry Station. The apparatus building was sold to the Pioneertown community in 1984 to house the community's fire engine.

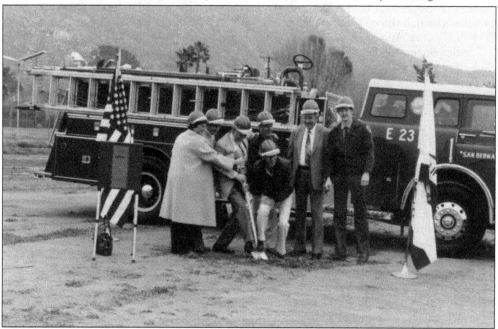

In January 1983, the Grand Terrace City Council members and California Department of Forestry Fire captain Phil DeClerck conduct ground-breaking ceremonies for Grand Terrace Fire Station No. 23. On August 16, 1983, the station was officially opened and placed in service. The new station was just east of the old location at 12167 Mount Vernon Avenue.

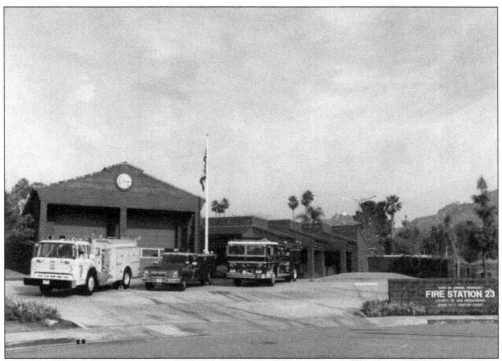

This c. 1988 photograph shows Grand Terrace Fire Station. Equipment includes, from left to right, Office of Emergency Services Engine 218, squad truck No. 23, and engine No. 23. Squad truck No. 23 was replaced in 1989 with a Pierce medium rescue unit. In December 1988, it was announced that, through the Grand Terrace Fire and Rescue Association's annual Christmas tree sales, enough funds were raised to purchase two additional rescue air bags capable of raising 25 tons.

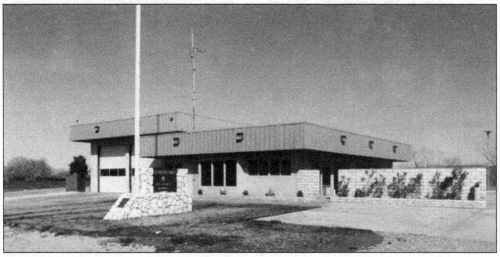

Helendale Fire Station was built in 1984 at a cost of $92,000 on 1.26 acres. Prior to construction, the station operated out of a maintenance shed for 12 years on property owned by the McCullogh Corporation. The area was annexed as an island in 1976 to County Service Area No. 38 under contract to the California Department of Forestry. In 1980, the newly formed Lions Club of Helendale raised money to purchase a four-wheel-drive rescue unit for the Helendale community.

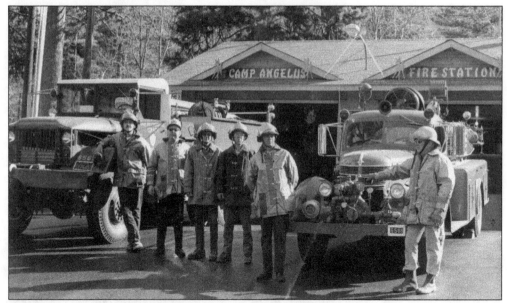

The Camp Angelus Fire Company formed in 1970 in County Service Area No. 38, Improvement Zone B, which was administered by the California Department of Forestry until 1998. The Seventh-Day Adventist Church donated three lots, and a station was built by volunteer community help. It was officially dedicated on Saturday, June 15, 1972. Firemen originally were located at an old leased residence until moving into the new station. At the time, the station equipment included a 1938 International fire truck and a 1942 Chevrolet fire truck.

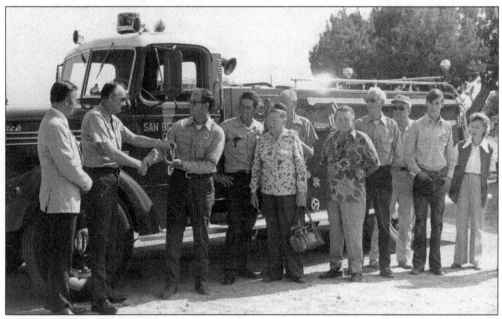

On July 9, 1975, the Pinion Hills fire company was presented with a 1949 pumper truck, which was purchased from the Long Beach Fire Department. Present at the presentation was Rex Griggs, California Department of Forestry ranger in charge and San Bernardino County fire warden, and James Mayfield, San Bernardino County First District supervisor. The engine put into service was a 1949 Class A Mack with a 1,250-gallons-per-minute pumper, capable of holding 500 gallons.

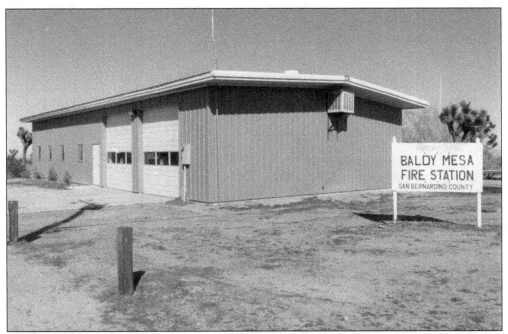

The Baldy Mesa County Service Area No. 38 Fire Station No. 16 was dedicated November 23, 1985. The volunteer fire company was established in 1972 and received its first fire engine in 1974. The engine was stored outside the home of a volunteer until the fire station was built in 1985. Baldy Mesa County Water District donated 1.22 acres for $1.

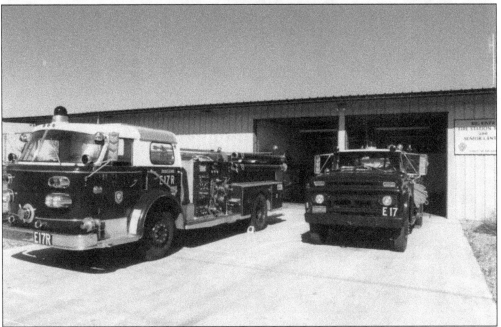

Big River Station No. 17 was dedicated March 16, 1984, on land donated to County Service Area No. 38 by Penn Phillips Big River Company. The station was built with Office of Community Development funds as a joint fire station and senior center. In 1993, a long awaited kitchen facility was completed.

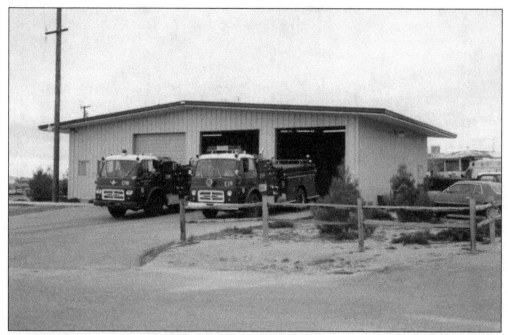

Homestead Valley Station No. 19 (Landers) was built in 1982 on 1.25 acres of land donated by community pioneer Rosiena Graves to San Bernardino CSA-38 with the understanding that if the property was no longer used as a fire station it would revert to her heirs.

Lytle Creek Station No. 20 was built on land sold to San Bernardino County by Bob Burlingame. Residents of Lytle Creek helped build the station with donated materials, of which $50,000 was paid by Southern California Edison for a 99-year lease for a switching apparatus room, $15,000 was donated by Bob Burlingame from money he received from sale of land, and $10,000 contributed by the board of supervisors.

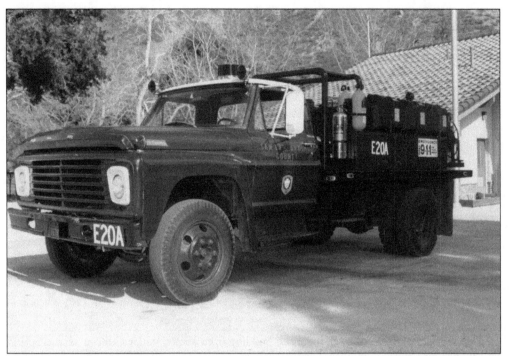

San Bernardino County obtained several of these US Forest Service model 50 engines. This 1972 Ford, No. 18357, had an 80-gallon-per-minute auxiliary pump and 250 gallon capacity. Prior to the construction of the current station, the Lytle Creek fire equipment was parked in a "fire barn" in the Happy Jack area of Lytle Creek.

In July 1980, Parker Dam Station No. 21 was built with Office of Community Development funds as a joint fire station and community center on land leased from the Bureau of Land Management to County Service Area No. 38, Improvement Zone J. At the time, Parker Dam Station No. 21 was within Battalion No. 4 of the San Bernardino County Fire Department CSA-38 and supervised by California Department of Forestry battalion chief George Pond.

CSA-38 leased a portion of the aeronautics building from Victor Valley College for the Spring Valley Lake Fire Station. The lease at the time was month-to-month. There were 15 volunteer firefighters. The move, besides allowing for expansion, provided fire equipment for the college's fire science program.

During 1978, the City of Needles contracted with the San Bernardino County Fire Department, California Department of Forestry, for fire protection services. The first CDF battalion chief to serve the community was Ray Snodgrass. The first piece of firefighting apparatus, a steam fire engine, was reportedly provided to the community by the Santa Fe Fire Department in 1902.

Park Moabi Station No. 34 was officially dedicated on April 19, 1986, during the Colorado River Daze event at Park Moabi, sponsored by the San Bernardino County Sheriff Station at Needles. The station was built by San Bernardino County Special Districts on Bureau of Land Management land leased to San Bernardino County Regional Parks.

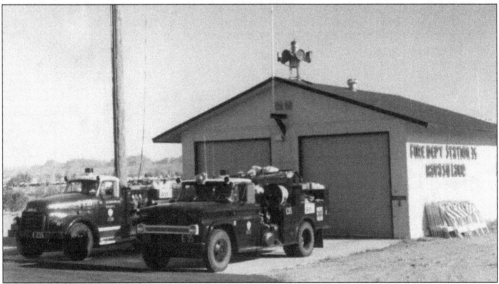

Havasu Lake Fire Station No. 35 and Community Friendship Hall was dedicated in October 1981. The community received its first fire engine on December 31, 1975, which was driven to town by First District supervisor Jim Mayfield. Jack and Jeanne Massey led the drive to obtain fire protection for the Havasu Lake community in 1975. At the time, 46 fire stations were under the supervision of the California Department of Forestry, San Bernardino County. Funds for construction were donated by Red Hodges to Fire Belles Inc., which, through volunteer labor, constructed the fire station.

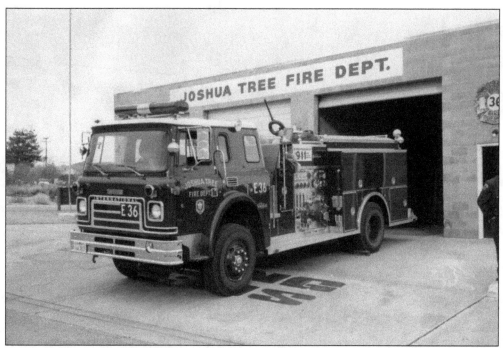

In March 1979, the San Bernardino County Board of Supervisors approved a contract between Joshua Tree Fire District and the California Department of Forestry for fire protection services under County Service Area No. 38. In January 1956, Harold Sherborn, Loyd Decker, Robert Garry, Harold Jost, and John L. Duncan were appointed to the newly formed Joshua Tree Fire District Board of Commissioners by San Bernardino County supervisor Magda Lawson.

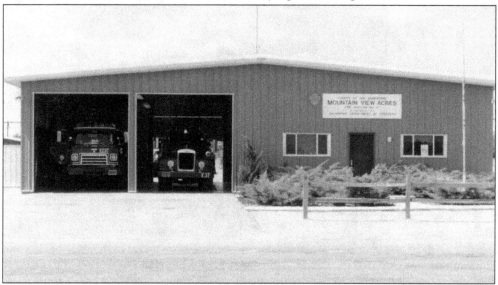

Mountain View Acres Station No. 37 was built in March 1980 by Cal Construction on land acquired in 1979 and originally owned by Victor Valley County Water District. The station was built with housing and urban development grants at a cost of $121,353. Mountain View Acres, an unincorporated area under the jurisdiction of the County Fire Warden California Department of Forestry, is west of the city of Victorville.

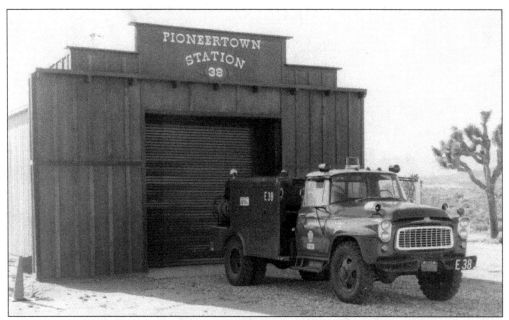

Pioneertown volunteer fire brigade was originally formed in 1977 with 22 dedicated volunteers under the supervision of California Department of Forestry fire captain Paul Tremblay. In 1979, County Fire Station No. 38 was established. The fire brigade purchased 1.25 acres, and construction costs were provided by San Bernardino County. In January 1984, the San Bernardino Board of Supervisors approved the purchase of an 800-square-foot building, formerly the Grand Terrace Fire Station. The building was disassembled and relocated to Pioneertown. The Pioneertown community was developed on a 13,000-acre tract in 1946 by a Hollywood syndicate.

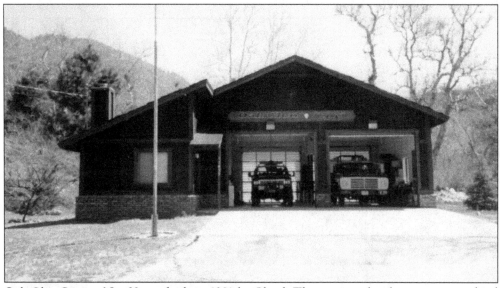

Oak Glen Station No. 39 was built in 1981 by Chuck Thompson, a local contractor, on land donated by the Wilshire family of Oak Glen. Local resident Paul Whittier donated funds for construction of the station. In September 1980, the San Bernardino County Board of Supervisors approved agreements allowing California Department of Forestry, as the county fire department, to operate and maintain a community hall and firehouse for the Oak Glen community.

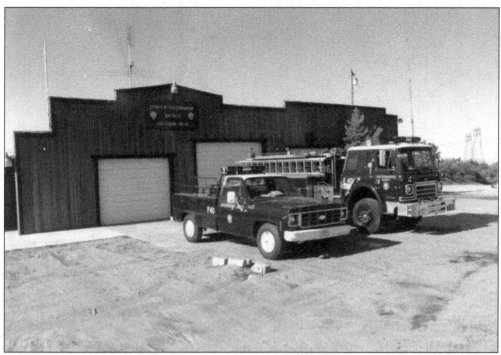

Oak Hills Station No. 40 was built by the Oak Hills Property Owners Association from donations. Property was originally leased at $1 per year with a 20-year lease. In July 1979, the property owners association was informed that the California Department of Forestry had requested a fire engine for the community and was awaiting approval from the board of supervisors. The station was located at 6584 Caliente Road in Oak Hills.

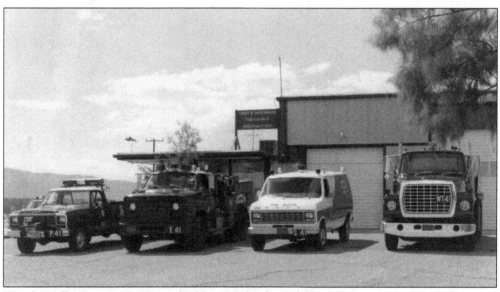

Wonder Valley Station No. 41 was built in 1960 by the California Department of Agriculture and was used as an agriculture inspection station until a new location was needed. Wonder Valley Fire District purchased the property for use as a fire station in 1965. There were originally two stations, Wonder Valley East Station No. 42 and West Station No. 41.

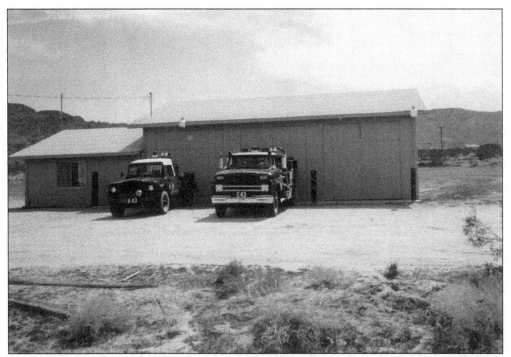

Johnson Valley Station No. 43 was built in 1980 by the Johnson Valley Improvement Association. The building was leased by County Service Area No. 38 in 1980 for use as a fire station for $160 a month. Prior to construction, the fire engine was kept at a volunteer's residence. The CAL FIRE engine in Lucerne Valley, located 25 miles west, provided training and additional emergency response to the community.

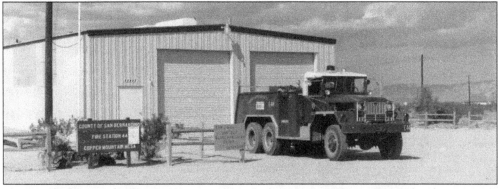

Plans for developing the Copper Mountain Mesa Volunteer Fire Department and making it a part of the Joshua Tree Fire District were recommended by the Joshua Tree Municipal Advisory Council and endorsed by the Local Agency Formation Commission in May 1981. The commission also endorsed annexation of 12 square miles in the area to CSA-38 under the California Department of Forestry. The fire chairman for the community said his group had raised more than $5,000 for a fire station. Most of the work of station construction was completed by the Over the Hill Gang of retired men and women. The company was activated on August 28, 1982, under the direction of the California Department of Forestry.

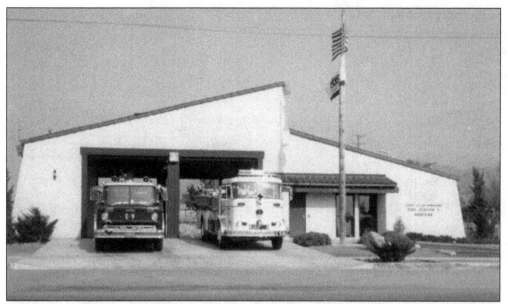

The current Mentone Fire Station No. 9, located at 1300 Crafton Avenue, was dedicated July 22, 1977. A new fire engine for the station arrived in December and was dedicated the same day as Yucaipa's engine. In 1992, a 1963 Seagraves engine was purchased from Barstow. In 1943, George Meers helped fabricate a 1937 Dodge fire truck with a 300-gallon tank; Meers was later Mentone's first fire station foreman.

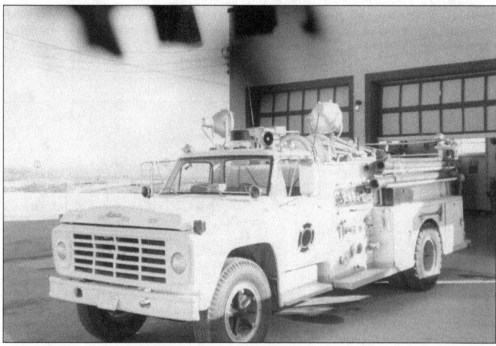

Boron Federal Prison Station No. 52 was part of the federal prison system under the US Department of Justice. Fire protection services were provided by California Department of Forestry, County Service Area No. 38, using trained minimum-security prisoners to staff a two-engine station. The prison fire station served the surrounding area.

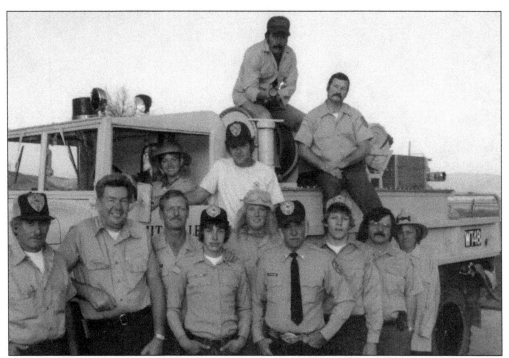

Summit Valley Volunteer Fire Station No. 48 was built in 1981 on land donated by Ray and Inga Wilder to San Bernardino County Service Area No. 38, Improvement Zone E. Prior to construction, the fire equipment was housed at the homes of the local paid-on-call firefighters. Originally under the jurisdiction of the Crest Forest Fire District, approval to form its own improvement zone was given by the Local Agency Formation Commission in 1972. This came as a result of Crest Forest's proposal to remove paid firemen from the area.

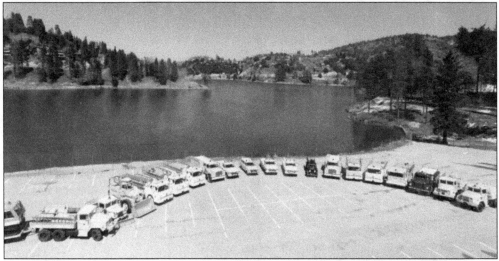

Crest Forest Fire District equipment is seen around 1979 at the San Moritz parking lot. The Crest Forest Fire District contracted with the San Bernardino County fire warden in 1978. The cooperative agreement between Crest Forest and County Service Area No. 38 California Department of Forestry was cancelled October 31, 1984. Crest Forest's first fire board was appointed in June 1929 by the San Bernardino County Board of Supervisors.

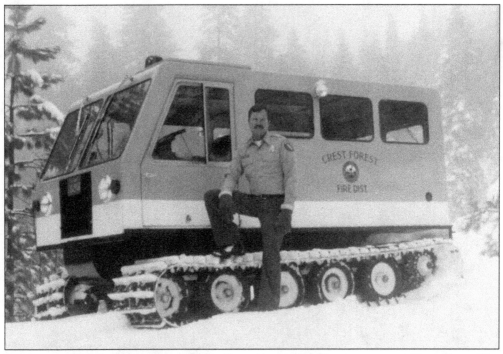

Fire captain Bob Burhle is seen with the Crest Forest Fire District snowcat. Crest Forest Fire District contracted with San Bernardino County Fire Department, California Department of Forestry, in September 1978. In 2015, Crest Forest Fire District Fire Board chose to dissolve the district and have services provided by the San Bernardino County Fire District. Crest Forest was one of the first five fire districts formed in San Bernardino County.

Crest Forest Fire District captain Dave Golder receives his CDF badge from ranger in charge and San Bernardino county fire warden Rex Griggs on becoming a CDF employee. In March 1983, Golder was promoted to battalion chief and was in charge of training and safety; he retired in 2009.

Four

STATE FORESTRY
LABOR CAMPS

In an effort to assist the thousands of unemployed families pouring into California as the result of the Great Depression, the California State Board of Forestry formed the first California state labor camps for jobless men and their families in the winter of 1931.

For four to six hours of work, the men received food, tobacco, and some clothing. In return, hundreds of miles of fuel breaks along with other forestry projects, such as campgrounds and telephone lines, were completed.

In April 1933, Congress established the Emergency Conservation Work program, which quickly became known as the Civilian Conservation Corps (CCC), lasting from 1933 to 1942. With the outbreak of World War II, select men from San Quentin and Chino prisons were moved to "honor camps." These camps eventually became today's Forestry Conservation Camps.

In San Bernardino, itinerant workers' camps in 1931 were established by the California Division of Forestry in Big Morongo Canyon, Yucaipa, and in Summit Valley. In 1933, CCC camps were established. These were supervised by the forestry agencies of the California Division of Forestry, now CAL FIRE, and the US Forest Service.

The first Forestry Conservation Camp in San Bernardino Ranger Unit was located at Pilot Rock near Crestline in 1959. In 1963, Owens Valley Camp, near Bishop, was completed. Don Lugo, which later became Prado Camp, opened. San Bernardino eventually took over operation of the Fenner Canyon Camp in 1979.

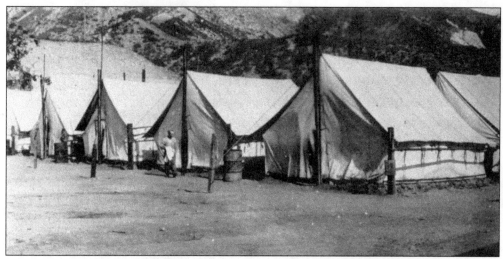

The Wildwood Civilian Conservation Camp was located at the Wildwood lodge in the Yucaipa area during the 1930s. This camp was supervised by division of forestry personnel; it completed many miles of firebreaks in the mountains above Yucaipa. State ranger T.O. Herman was in charge of the camp with 150 men. Bread for all the camps was made at the Del Rosa Conservation Camp's bakery.

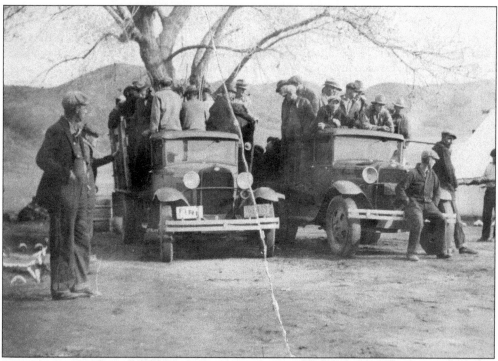

In December 1931, the California Division of Forestry opened the itinerant workers' camp in Yucaipa. Other camps were planned for Etiwanda and Riverside County at Beaumont. The Yucaipa Camp had room for 100 men. State ranger in charge Russell Z. Smith stated, "There are no Shirkers or Reds among them, the men won't tolerate them." At the time, communist sympathizers were active in the unemployed workforce.

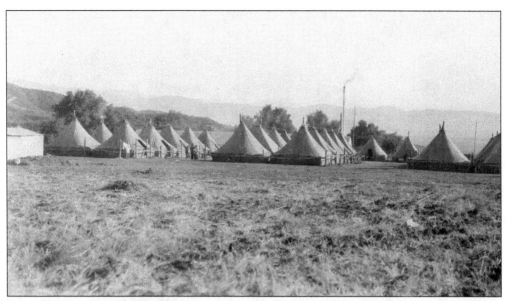

Yucaipa's itinerant workers' camp was supervised by California Division of Forestry from 1931 to 1934. Camps were located near the South Mountain Water Company. The brick building of the South Mountain Water Company served as the kitchen for the camp. Itinerants coming to the area were sent to the Yucaipa Camp and given only board and lodging for their work.

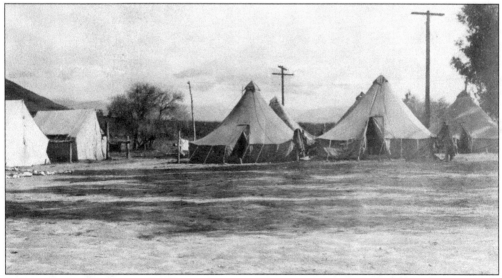

Prior to sending workers to the itinerant camps, all were sent to a clinic for physical exams. Only after receiving health certificates were they sent to camps. At the time, all temporary applicants for camp work were sent to the county hospital for examination through the offices of the superintendent of the hospital.

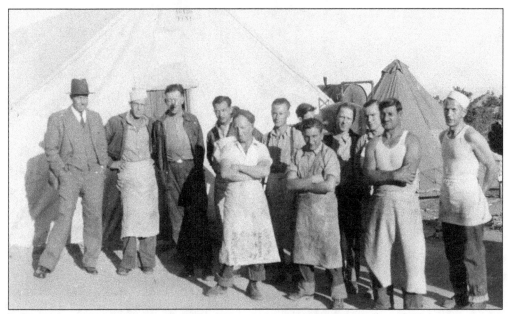

In December 1930, the Yucaipa Camp had 70 men. Men at the camp conducted "Kangaroo Court" when considering misdemeanor offenses within the camp. In the Yucaipa and Beaumont camps, the men took care of their own troubles. A grumbler, troublemaker, or agitator was speedily removed from the camp and told to move along.

Food, lodging, and tobacco were furnished for the men for a half day's work. It was hoped that they would soon be able to provide shoes and clothing for extreme needs. The Salvation Army provided a night and morning meal for those who were willing to work two hours. They dispensed with the work requirement if the transient asked to go to the Yucaipa Camp.

Richard Jackson started working for San Bernardino County Forestry in June 1927 as a patrolman for the Oak Glen District. Jackson also assisted with operations at the itinerant workers' camps in the Yucaipa area. He served as a district ranger for the California Division of Forestry until his retirement in 1938.

Chino Civilian Conservation Camp, located in Soquel Canyon, was constructed by the California State Forestry Department in 1938. About 200 young men were provided room and board for their work. Another camp, a remnant of the California State Relief Administration set up in 1935, was located south of the new Chino prison. There were 42 barracks, with each accommodating 8–12 men.

In November 1933, the first of the itinerant labor camps for transient indigents from the San Bernardino Base No. 1, located on South G Street, was established in Big Morongo Canyon. Camp No. 2, located on Ray Bolster's ranch, had a capacity of 165 workers, who received free meals and lodging. The regular dinner consisted of sauerkraut and frankfurters, potatoes, creamed peas, macaroni salad, marble cake, bread, butter, and coffee. The workers built firebreaks and trails and provided forest protective work.

Pilot Rock's conservation camp, located in Miller Canyon north of Crestline, is seen shortly after construction in 1960. In 1934, this location was used for Miller Canyon's conservation camp. The camp, located two miles above Cedar Springs Park and five miles below Valley of the Moon, boasted one of the largest construction records in the West.

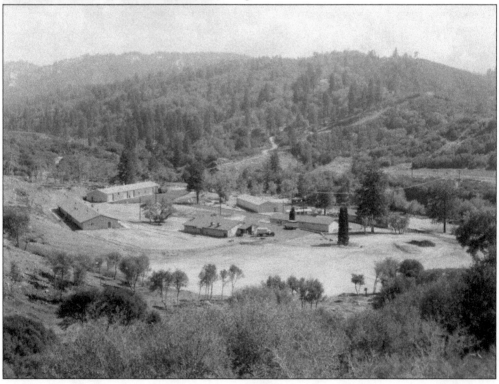

Two residences were also constructed on Waters Drive in the Crestline community. In 2011, this residence was converted into a CAL FIRE forestry fire station. In the past, the residences provided housing for Pilot Rock's camp staff. Pilot Rock Camp, as with others, employs firefighters who may travel long distances. The state residences provide modest housing for those wishing to relocate closer to work.

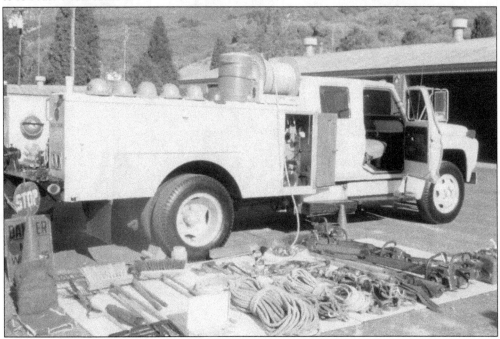

Pilot Rock Camp's insect control vehicle also had tree felling and climbing equipment. Insect-infested trees near structures are felled and removed using this equipment. Fire crew captains assigned to the insect control program receive extensive training to safely climb and remove hazardous trees near structures.

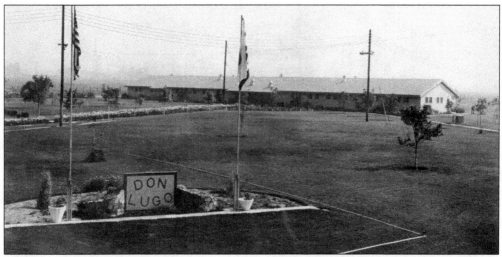

In August 1969, the California Division of Forestry paid staff and fire crew at Don Lugo Camp were moved to Oak Glen's conservation camp since the Oak Glen Job Corps Center closed on May 13, 1969. From 1971 until January 21, 1972, the California Department of Corrections used Don Lugo as a work furlough center for the Chino Institute for Men. It later reopened in April 1972 as Prado's conservation camp.

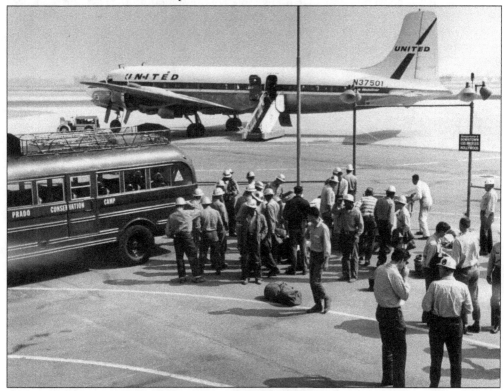

Prado Conservation Camp crews are seen preparing to board a flight to Northern California. In August 1977, department of forestry crews and fire engine were flown north, some on commercial aircraft and others on C-130 cargo jets, from Ontario International Airport. Three C-130s carried three engines with crew to Yreka in two and a half hours.

Southern California Youth Training Center opened in the San Bernardino County's community of Chino in 1960. In 2010, after 50 years of operation, the center was closed and incorporated into the California Institute for Men as an adult correctional facility.

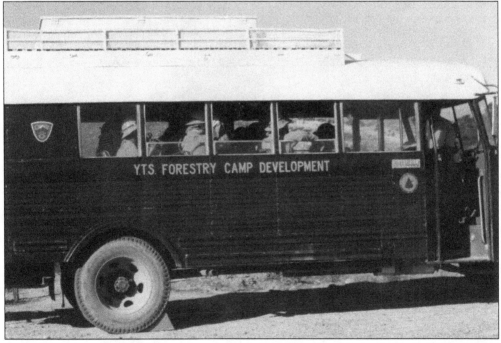

A youth training center bus is preparing to transport crew to a project site for fire line construction training and work projects. The vehicle was designed with sufficient storage for all the equipment the crew would need during fire suppression operations. The buses also carried adequate supplies to be self-sufficient for 48 hours.

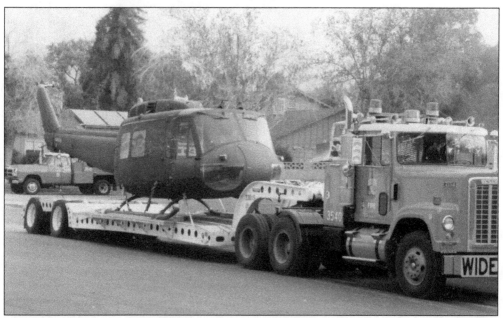

In 1988, a cooperative agreement was signed between San Bernardino County Sheriff's Aviation and the California Department of Forestry, under compliance with the Forestry Assistance Act, for the loan of a Bell EX-1H helicopter for an indefinite period. It was used for rural and wildland firefighting. The helicopter was based at Prado Conservation Camp in Chino and initially staffed with California Department of Correction inmates from Prado.

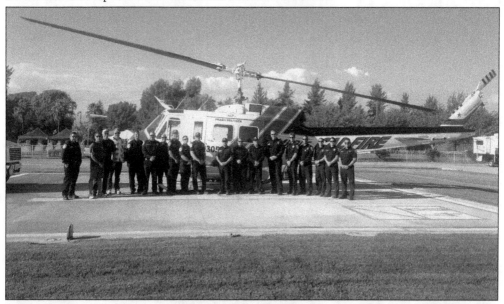

In September 2014 at Prado, new state funding supported the employment of a heli-tac crew of firefighters for helicopter No. 305. From left to right are Shawn Newman, Mike Matta, Mark Grisamore, Wes Gardner, Dan Reese, Jeff Veik, Steven Shaw, Casen Bills, Mike Shaw, Dustin Gill, Arnold Ramirez, forestry pilot Desiree Horton, Chief Bill Payne, CAL FIRE San Bernardino chief Rod Bywater, Garett Armsby, Joe Ferreira, Cameron Dubois, Tanya Vasquez, and Sergio Rivera.

Fenner Canyon Conservation Camp had its beginnings in 1902 during the mining era and is named after Fred C. Fenner, superintendent of the Big Horn Mining Co. In 1979, the California Department of Forestry, in partnership with California Youth Authority, occupied the camp as a youth facility. In 1990, it was converted to an adult institution.

Fenner Canyon crews line up for inspection. Each crewman is assigned a specific tool and, on command from their crew leader, will tool out in order within a given time frame. Prior to arriving at their assigned camp, the California Department of Correction inmates receive one week of classroom training and a week of field training. Once assigned to a crew, a minimum of four hours per week of advanced training is provided.

Ground-breaking ceremonies for the Fenner Canyon Job Corps Center were held in March 1965. At the time of construction, Fenner was operated by the Angelus National Forest. It was the first center opened in Southern California under the nationwide economic opportunity program. Pictured is the gymnasium, which hosted basketball tournaments.

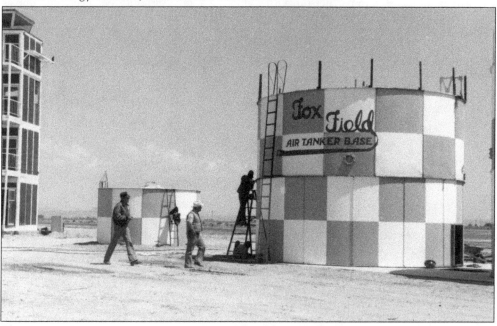

This Fenner Canyon crew is constructing wildland fire retardant tanks at Fox Field air tanker base in Los Angeles County. In the past, fire retardant was made of borate salt, which was found to sterilize the soil and was toxic to the environment. Today's retardants use ammonium sulfate or ammonium polyphosphate with a thickener. Fox Field is located in northern Los Angeles County in the community of Lancaster.

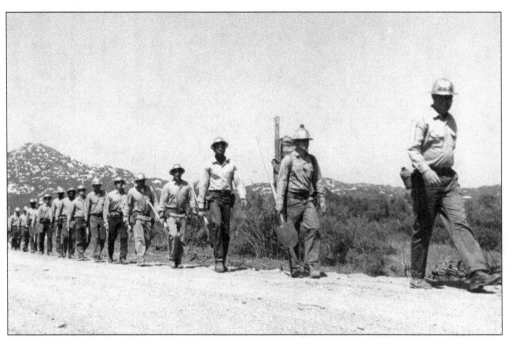

Southern California Training Center inmates learn the art of hiking in fire line order, more familiarly known as "hook line order." The term hook line comes from the earlier years when the brush hook tool was the lead fire tool in line. In this picture, the second person in line was the radio man or swamper. The pack, depending on radio type, could weigh as much as 60 pounds.

In 1964, inmates of the California Institute for Men are learning the techniques of felling trees at the Southern Conservation Training Center in Chino. Trees in Southern California are under constant stress from many factors, including drought, insects, and pollution. This tree was cut down due to an infestation of insects that eventually killed it. This was an effort to help slow the spread of insects to other trees.

115

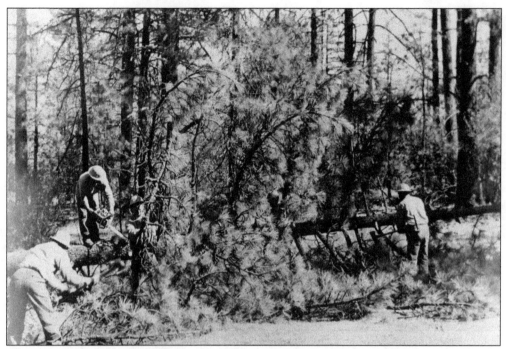

After felling a tree, Southern Conservation Training Center inmates start the process of liming and bucking. At the time in 1964, a combination of the chemical Lindane along with diesel fuel was sprayed into the tree to kill the insects. The limbs were then run through a brush chipper.

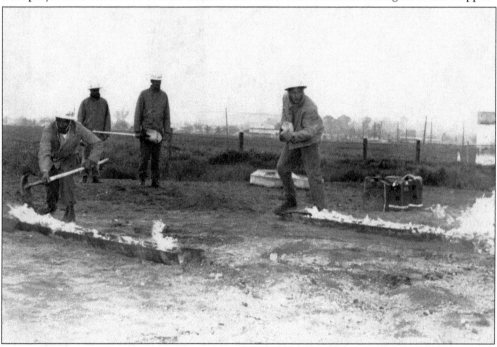

Pictured is a live fire training exercise that simulated a wildland fire line, a "hot line," at the Southern California Conservation Training Center in Chino. This drill taught firefighters how to throw dirt to better extinguish a fire. Troughs filled with diesel fuel were used for the fire line simulation.

Five

Inyo and Mono Counties

From the appointment of US Forest Service and California State Fish and Game officials acting under the authority of the California state forester as fire wardens in 1913 until 1944, very little information is available regarding the California Division of Forestry in Inyo and Mono Counties. During World War II, the California Division of Forestry units of Fresno and Tulare provided a limited number of firefighting tools and equipment through the California Office of Civil Defense.

On June 28, 1955, a meeting was held in Bishop that included US Forest Service, Bureau of Land Management, Los Angeles Department of Water and Power, Inyo County, and California Division of Forestry officials to discuss fire protection and coordination within Inyo and Mono Counties.

As a result of this meeting, the Mono County supervisors on July 6, 1955, and the Inyo County supervisors on August 2, 1955, formally requested that the state forester determine watershed lands qualifying for classification as State Responsibility Lands.

In the summer of 1956, forestry firefighter foreman Bruce Morrow of Fresno County was appointed to Inyo and Mono Counties to gather information relating to landownership outside of national forest and local fire control actions currently in place. Morrow completed his assignment on October 16, 1956.

The California state forester, after study of the information provided by Morrow, released a report relating to Inyo and Mono Counties that provided for the establishment of responsibility for the California Division of Forestry in Inyo and Mono Counties.

The first mutual aid agreement was signed by the California Division of Forestry, US Forest Service, Bureau of Land Management, and the Los Angeles Department of Water and Power for the purposes of providing wildland fire protection within Inyo and Mono Counties.

On May 16, 1958, Cecil Metcalf, the deputy state forester, gave a speech to the California State Senate Fact Finding Committee on Commerce and Economic Development that ultimately became the catalyst for the establishment of the Owens Valley Camp and future CAL FIRE facilities in the Owens Valley.

CALIFORNIA STATE FIREWARDENS.

* Forest Service Officials. § Fish and Game Officials.

† Paid County Officials. ‡ Paid by Associations.

LIST OF APPOINTMENTS UP TO MARCH 1, 1918.

INYO COUNTY.

Allen, Andrew A.*	Lone Pine
Crow, Glenn H.*	Round Valley
Eaton, H. O.	R. F. D., box 13, Bishop
Hogue, A. H.*	Bishop
Johnson, O. C.	Lone Pine
Lilly, R.	Bishop
Logan, R. H.*	Big Pine
Overhulser, E. C.	Lone Pine
Parkinson, Roscoe*	Lone Pine
Summers, Charles, Jr.,*	Bishop
Williams, Benjamin	Bishop

MONO COUNTY.

Clark, Fred B.*	Mono Lake
Fulton, Charles W.*	Mono Lake

This is an early list of appointed fire wardens to Inyo and Mono Counties. In 1918, A.H. Hogue served as the US Forest Service supervisor in Bishop. Hogue was a pioneer resident of Fresno and Madera Counties. Charles W. Fulton served as Mono County land surveyor.

Curtis E. Lindley

Lindley, Kings Ranger, Goes To New Inyo Post

McClatchy Newspapers Service

SACRAMENTO — Curtis E. Lindley, chief ranger for the state division of forestry in Kings County, has been named to head the newly created Owens Valley ranger unit, with headquarters in Bishop, Inyo County.

The division announced yesterday a successor to Lindley in Kings County is yet to be determined in consultation with the county's board of supervisors.

In addition to the usual forestry duties, Lindley will develop work programs to be carried out by corrections work camp crews to be activated in Mono and Inyo Counties.

On August 15, 1963, Curtis E. Lindley was appointed state forest ranger to the newly created Owens Valley Ranger Unit. Camp construction started in August 1962. His first office was located on Line Street in Bishop. Ranger unit chiefs after Lindley were John Clark, Ivan Phillips, John Ferguson, and Don Escher.

In July 1976, Owens Valley forestry inmate crews provided hundreds of hours of labor in construction of the Pacific Crest Trail. To complete the project, crews camped along sections of the trail for a week at a time. Forestry fire captain Emerick supervised. Over the years, Owens Valley crews have assisted with rescue operations of several injured hikers from remote trails and campsites in Inyo and Mono Counties.

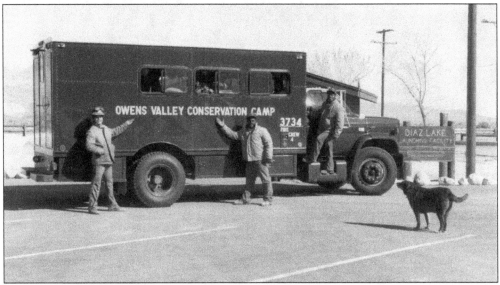

Owens Valley crew No. 4 is seen at Diaz Lake south of Lone Pine, California, along Highway 395. In 1991, CAL FIRE Owens Valley crews provided 49,312 inmate work hours on projects for Inyo County, ranging from mosquito abatement, campground maintenance and repair, and fire hazard reduction along roads and highways. Another 18,600 inmate work hours went toward the annual cleanup and fire hazard reduction at state fish hatcheries.

Miss Fire Prevention stands next to the Owens Valley Ecology Center's camp sign. In April 1971, Gov. Ronald Reagan announced the creation of the California Ecology Corps, which was to be made up of conscientious objectors to the draft. On July 7, 1976, Gov. Jerry Brown replaced the Ecology Corps with the California Conservation Corps. The California program was modeled after the federal CCC during the New Deal of the 1930s.

Crews from Owens Valley Camp took part in building the Conservation Building at the tri-county fairgrounds in Bishop during the Ecology Corps in September 1966. The Ecology Corps from Owens Valley spent many hours in Death Valley constructing boardwalks around the sensitive areas and over wetlands of salt grass. Ecology Corps crews camped in the area each week while constructing the boardwalks.

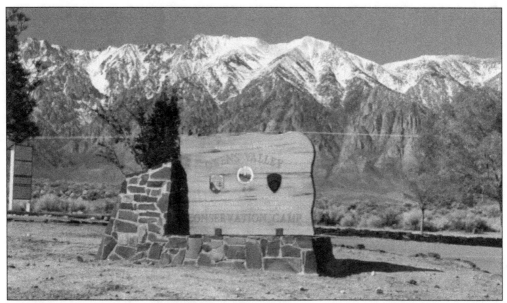

In 1959, members of the Inyo and Mono chambers of commerce, boards of supervisors, California Department of Corrections, and the California Division of Forestry met in Bishop to identify a suitable location for the Inyo Mono Conservation Camp. Three potential sites were selected; the Marion property on Highway 6, seven miles north of Bishop; Round Valley on Highway 395, seven miles northwest of Bishop; and the Riley property on Fish Slough Road, ten miles north of Bishop. Ultimately, the Round Valley site was chosen.

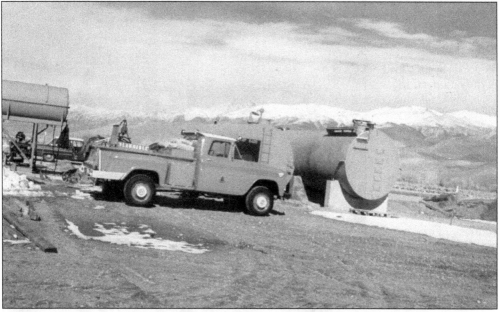

Initial construction of the fire retardant base was constructed at the Eastern Sierra Regional Airport, Bishop's airport, by the California Department of Forestry. The camp supported firefighting air tankers in the Owens Valley area. In 2008, Owens Valley crews provided most of the labor for preparation of the runways for maintenance and asphalt replacement. The reload base is on 7.88 acres of the airport property and is currently operated by the US Forest Service.

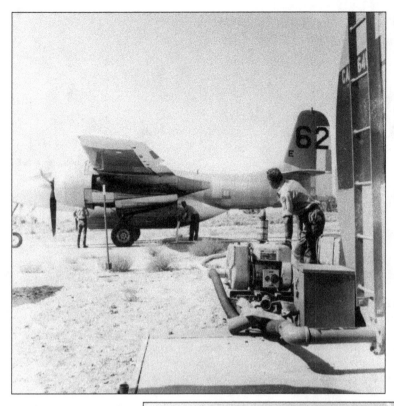

Tanker No. 62 is reloading at the Bishop Reload Base. The Grumman F7F-3 had a single fuselage with 800-to-1,000-gallon retardant capacity. There were five F7F-3s operating in California by early 1970. Currently, all CAL FIRE fixed wing aircraft pilots are provided under contract, while helicopter pilots are CAL FIRE employees.

TBM air tanker No. 58 stands by for a load of fire retardant. In 1958, the California Division of Forestry contracted for four TBM air tankers, which have a capacity of 600 gallons. By the early 1970s, the CDF had a total of 16 TBMs under contract. Concerns were developing with maintenance, and with several accidents, CDF had to evaluate a new aircraft for general use. The CDF started its conversion to the S-2 air tanker in 1973 after years of evaluation.

Six

FIRE PREVENTION, INFORMATION, AND EDUCATION

For many years, it has been the goal of CAL FIRE to provide effective fire prevention and fire safety and to educate citizens about protecting natural resources and watershed from fires in the state of California.

Indirectly, the firefighters of CAL FIRE have influenced citizens of San Bernardino County through the use of local media, county fairs such as the San Bernardino National Orange Show, and public events featuring Smokey Bear.

The State Forestry Bureau sent forestry equipment for display at the San Bernardino National Orange Show in 1928. Displays of cutting timber and reseeding showed the cause and effects of forest fires and the different methods that could be used to prevent them.

For more than 25 years, CAL FIRE has participated in public safety demonstrations at the San Bernardino County Fair at the Victorville fairgrounds. CAL FIRE's booth includes a prize wheel for youth who correctly answer fire prevention questions from Smokey Bear.

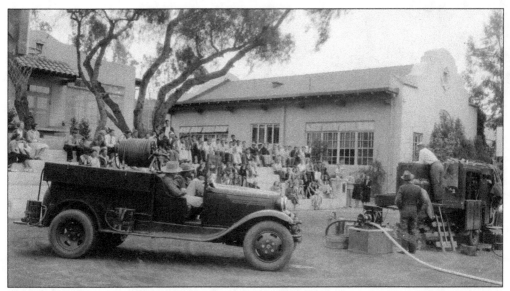

Fire truck and pump demonstrations for Yucaipa High School were conducted in 1932. Prevention demonstrations were conducted in 14 towns throughout the San Bernardino Valley. Special attention was given to demonstrations and lectures on prevention of structure fires. The demonstrations were conducted primarily for those communities that had no municipal fire protection. (Courtesy of the Marian Koshland Bioscience and Natural Resources Library, University of California, Berkeley.)

In March 1930, a series of demonstrations was arranged by county forester George Park in cooperation with farm bureau representative A.L. Campbell. At the demonstration, Park used the most modern equipment for extinguishing brushfires. There was also an inspection of firebreak work and a tour of the recently completed conservation and spreading grounds constructed by San Bernardino City. This picture was taken at the demonstration in San Bernardino near 40th Street and Valencia Avenue. (Courtesy of the Marian Koshland Bioscience and Natural Resources Library, University of California, Berkeley.)

Fire warden George Park instructs residents of the west end of San Bernardino County, including the communities of Ontario, Etiwanda, Cucamonga, Upland, and Chino, in the use of modern firefighting equipment. During the series of demonstrations, emphasis was directed toward the need for aggressive fire hazard reduction, fire prevention, and firefighting equipment. (Courtesy of the Marian Koshland Bioscience and Natural Resources Library, University of California, Berkeley.)

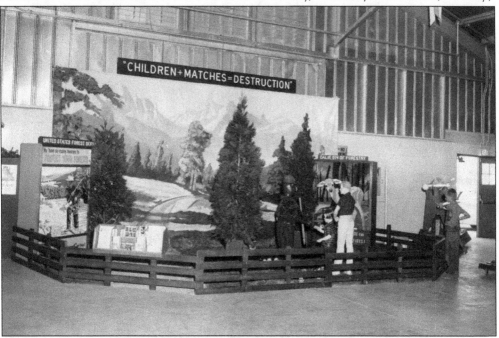

For many years, the California Department of Forestry participated at the San Bernardino County National Orange Show with fire prevention exhibits. During the 26th San Bernardino National Orange Show, from February 21 through March 1, 1936, the California Division of Forestry supported the San Bernardino City Fire Department with a state forestry engine on standby fire patrol at the event.

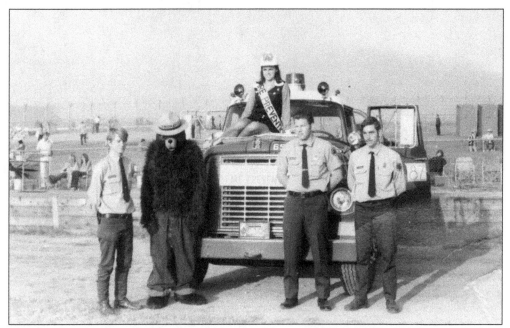

Miss Fire Prevention is pictured at the Ontario Motor Speedway Miller 500 Race with, from left to right, Steve Dale, Smokey Bear, Duane DeClerck, and Tom Connor. In November 1972, with their brand new fire engine, Duane DeClerck's state forestry crew from Devore Forestry Fire Station, along with Smokey, Smokey Jr., Miss Fire Prevention, and Miss Fire Control, were entered into the Christmas Parade of Stars in Hollywood.

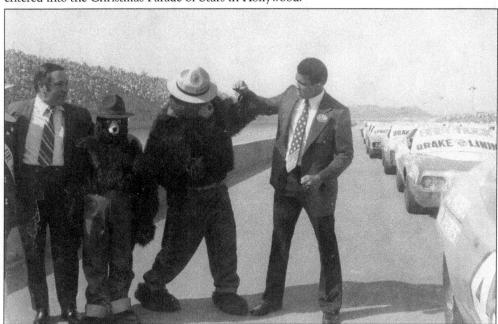

At the Ontario Motor Speedway Miller 500 Race on March 5, 1972, Smokey Bear and Muhammad Ali spar for the crowd. Andy Granatelli and Smokey Jr. observe. Smokey Jr. was used in the 1950s and 1960s along with Smokey. It was determined the smaller costume did not scare small children as much.

Utilizing registered members of local Radio Emergency Associated Citizens Teams to patrol wildland areas for the early detection of wildfires, the California Department of Forestry established the Red Flag Patrol in 1974. The volunteer cars were given a Red Flag Patrol magnetic sign for each side of the car and a red pennant for the antenna. The program was funded through the San Bernardino Junior Women's Club.

California Department of Forestry's Smokey and the San Bernardino Spirits mascot are seen at a baseball game. Over the years, firefighters of the California Department of Forestry, along with the San Bernardino National Forest and Smokey Bear, have attended Spirits baseball games at Fiscalini Field. On June 29, 1993, photographs of Smokey and the Spirits mascot were given to the first 1,000 fans at the game.

Visit us at
arcadiapublishing.com

Printed in the USA
CPSIA information can be obtained
at www.ICGtesting.com
LVHW061230290823
756501LV00031B/74